Hidden Meanings of Love and Death in Chinese Painting
Selections from the Marilyn and Roy Papp Collection

Shen Zhou (1427 – 1509)

Hidden Meanings of Love and Death in Chinese Painting

Selections from the Marilyn and Roy Papp Collection

Chun-yi Lee

PHOENIX ART MUSEUM

Hidden Meanings of Love and Death in Chinese Painting: Selections from the Marilyn and Roy Papp Collection
is published in conjunction with an exhibition organized by the Phoenix Art Museum, Phoenix, Arizona.

Phoenix Art Museum
27 April – 2 September 2013

This catalog is funded by the Asian Arts Council of the Phoenix Art Museum.

Contributors:

Janet Baker Curator of Asian Art
 Phoenix Art Museum
Claudia Brown Professor of Art History
 School of Art
 Herberger Institute for Design and the Arts
 Arizona State University
Chen Liu Post-Doctoral Fellow
 The Marilyn and Roy Papp ASU-Phoenix Art Museum-Asian Arts Council
 Chinese Painting Program

Editing:
 Anne Gully

Design:
 Mookesh Patel

Photography:
 Ken Howie

Lithography:
 Prisma Graphic Corporation

Cover:
 Sections of *Dreaming in the Xiaoxin Pavilion* (catalog number 26) by Pan Xuefeng

Library of Congress Cataloguing-in-Publication Data:
 Li, Junyi, 1965-
 Hidden Meanings of Love and Death in Chinese Painting: Selections from the Marilyn and Roy Papp Collection /
 Chun-yi Lee.
 pages cm
 Issued in connection with an exhibition held April 27-September 2, 2013, Phoenix Art Museum,
 Phoenix, Arizona, organized by the Phoenix Art Museum.
 Includes bibliographical references.
 ISBN 0-9844081-5-0 (978-0-9844081-5-3 : alk. paper)
 1. Love in art--Exhibitions.
 2. Death in art--Exhibitions.
 3. Painting, Chinese--Ming-Qing dynasties, 1368-1912--Exhibitions.
 4. Papp, Roy--Art collections--Exhibitions.
 5. Papp, Marilyn--Art collections--Exhibitions.
 6. Painting--Private collections--Arizona--Exhibitions. I. Phoenix Art Museum. II. Title.
 ND1460.L68L5 2013
 759.951'07479173--dc23
 2013008146

Printed in the United States of America

Contents

Preface 7
James K. Ballinger

Dedication page 9

Introduction 10
Chun-yi Lee

Hidden Meanings of Love 17
Chun-yi Lee

Hidden Meanings of Death 49
Chun-yi Lee

Catalog 85

Select Bibliography 92

Acknowledgements 94

Visiting Scholars 95
The Marilyn and Roy Papp Chinese Painting Program

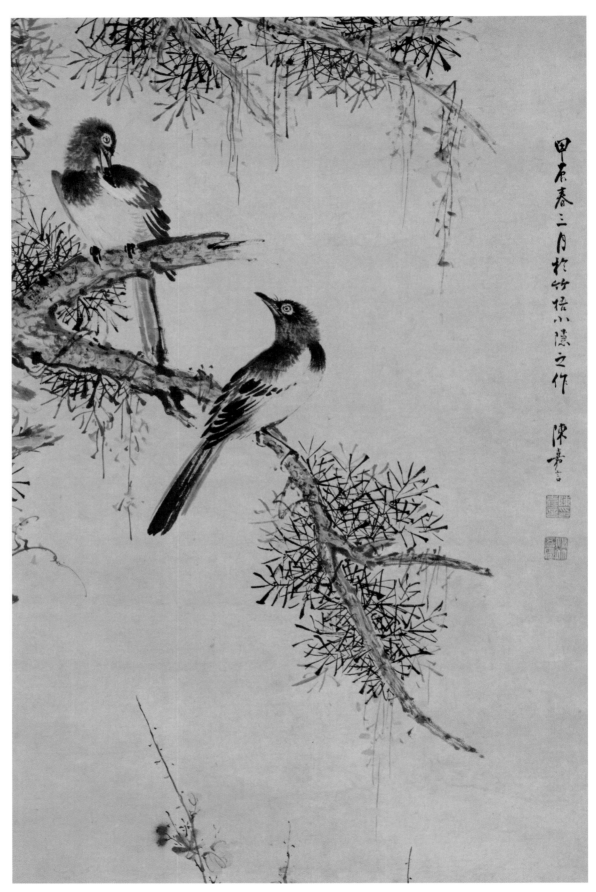

甲辰春三月於竹梧小隱之作　陳嘉言

Chen Jiayan (1599 – after 1679)

Preface

Roy and Marilyn Papp came to Phoenix in 1977, when Phoenix Art Museum was a young institution poised for growth. They were among those who gave the Museum the impetus that made our amazing growth over the past thirty years possible. By 1983 they had begun, at Marilyn's suggestion, to collect Chinese paintings, and by 1985 they had joined with others to found the Asian Arts Council of the Phoenix Art Museum. Marilyn would go on to lead the Docent Program as President, and Roy would serve both as Trustee and President of the Board of Trustees of Phoenix Art Museum.

Marilyn and Roy Papp built an important collection of Chinese paintings representing the past five hundred years. They formed the collection over twenty-five years, ultimately selecting about two hundred works representing the highest artistic expression of China's Ming and Qing dynasties. From the start of their collecting, Marilyn and Roy Papp chose to involve scholars at Arizona State University and at Phoenix Art Museum. Thus, since at least 1984, art historians at both institutions have conducted research relating to paintings in the collection, with several resulting publications and exhibitions. The scholarship of ASU Professor Emeritus Ju-hsi Chou, also Emeritus Curator of Chinese Art at the Cleveland Museum of Art, and Dr. Claudia Brown, then Curator of Asian Art at Phoenix Art Museum, was essential to building the collection and to publishing three catalogs: *Heritage of the Brush* (1989), *Scent of Ink* (1994), and *Journeys on Paper and Silk* (1998). ASU students have written MA theses and doctoral dissertations based on works in the Papp collection, and an annual seminar has been held for the past seven years to present scholarly papers in the history of Chinese painting. These events offer the rare opportunity for everyone attending to view selected paintings together, without barriers, and to engage in a lively exchange.

Since 2000, under the curatorship of Dr. Janet Baker, Marilyn and Roy Papp have given more than thirty paintings from their collection to Phoenix Art Museum. These gifts have greatly enhanced the Museum's existing collection of Chinese painting donated by Jeannette Shambaugh Elliott, adding breadth and depth and expanding the range of date as far back as the fifteenth century. Several works featured prominently as major gifts in honor of Phoenix Art Museum's 50th Anniversary Celebration in 2009. Dr. Baker and Dr. Brown have built a strong collaboration at the Museum that has served to highlight the Papp collection through exhibitions, programs and scholarship during the past thirteen years.

In her obituary for Roy, who died in 2011, Marilyn wrote that "travel and philanthropy were his greatest interests." They were able to combine these passions with their interest in collecting Chinese paintings. Exhibitions from their collection have been shown in New York, Chicago, Paris, and Berlin; paintings from their collection have been featured in exhibitions held in New York, Denver, Honolulu, and Hong Kong. There were no fewer than twenty-four shows, all organized by Phoenix Art Museum, and Roy and Marilyn attended every opening! In this endeavor, and in their other travels during their sixty years of marriage, the Papps visited fifty-eight different countries.

New and unprecedented scholarship is offered here by Dr. Chun-yi Lee, Assistant Professor, National Taiwan Normal University. His iconographical studies take the history of Chinese painting into previously unexplored areas, identifying themes relating to the fundamental concerns of love and of death. By drawing out these themes, he offers us a new way of looking at Chinese painting and an unexpected richness of meaning.

Through Dr. Lee's innovative scholarship, we come to understand how Chinese artists embedded a code of meanings, inspiring the viewer to contemplate the worthiness of a long life, the valor of perseverance and the necessity of determination. In subjects of flowers and plants we find emblems of wealth and nobility, loyalty and love. In landscapes and garden scenes, we are led to contemplate the fleeting nature of life against the background of continuity and permanence. Together these themes signify the ongoing power of life.

We are grateful to Marilyn Papp, and her late husband Roy, for sharing these treasured works of art with Phoenix Art Museum and the public. Drs. Baker and Brown are to be commended for their oversight of the collection and for guiding scholarship about the collection. We also thank the Asian Arts Council of the Phoenix Art Museum for providing support for this publication.

James K. Ballinger
The Sybil Harrington Director, Phoenix Art Museum

Dedication

Asian Arts Council of Phoenix Art Museum
is proud to dedicate this publication
in honor of
Marilyn and Roy Papp
in recognition of their many years
of generosity, service and commitment
to the field of Chinese Painting.

Introduction

Love and death are the two mysteries of life. Chen Duxiu 陳獨秀 (1879-1942), the early 20th-century Chinese thinker, once wrote:

> Alas, there are two perplexing questions in human life – one is love, and one is death. Death and love are inevitable in life. Buddhism talks about the twelve predestined fates, which roughly mean: 'Death from old age comes with life, life comes with love, and love comes with the unknown'... The reason for that cannot be grasped by common sense and the notion to get rid of death and love is indeed preposterous. One's life, filled with goodness and badness, with sadness and happiness, is so complex and tangled, and therefore cannot be explicated.

（嗟乎，人生最難解之問題有二，曰愛，曰死。死與愛皆有生必然之事，佛說十二姻緣，約其意曰：老死緣生，生緣愛，愛緣無明… 其理為常識所難通，則絕死棄愛為妄想，而生人之善惡悲歡，遂紛然雜呈，不可說其究竟。）[1]

The poignant and fatalistic remark by Chen Duxiu puts forward one truly important issue that everyone must face in their lives – the perplexities of love and death, which have haunted human minds indiscriminately from naïve innocence to the very ripest wisdom.

There is hardly anything as amazing and as dreadful as love and death. Everyone is born to love and die. Love is an indispensable element in human life, forming the basis of interactions with others. And death puts an ultimate end to all human relations and affections. Love and death are therefore the main concerns of mankind, if not their primal instincts or drives as propounded by Sigmund Freud (1856-1939).[2] Throughout history and across cultures, these two pervasive and compelling phenomena have been used and exploited through words, music and visual arts to contemplate the essence of human existence. The themes of love and death, which are treated and presented in a rich variety of styles and content, resonate powerfully with readers, listeners and viewers by evoking their overwhelming sentiments. It is no wonder that love and death have been two of the most obsessively recurring themes in the various art forms. Many of the most arresting images and stories from the world's cultures are inextricably associated with love and death, dealing with the ensuing psychological and intellectual experiences of individuals and of mankind as a whole.

Considering the preoccupations of love and death in human society, it is reasonably enticing for art historians to probe the important roles they played in artistic creation and reception. The visual representations and symbolism of love and death in Western art have hence attracted great scholarly attention, and related studies and exhibitions of artworks from the ancient periods to modern times have enhanced our understanding of their significance in Western cultures.[3] However, the scholarship of these two important themes in Chinese art, especially in Chinese literati painting, is still in its infancy.

Compared to other cultures, the traditional Chinese attitudes toward love and death are highly restrained and sometimes demonstrate certain negative emotional burdens. In a Confucian-based society, *li* 禮 or the rules of proper behavior were promoted and implemented effectively to guide people's personal and social practice while shaping their thinking.[4] Human relationships under the guidelines of Confucian propriety were built upon love and developed and maintained through *jing* 敬, the act of reverence to others.[5] In the *Liji* 禮記 (Book of Rites), Confucius elucidates: "With the ancients in their practice of government the love of men was the great point; in their regulation of this love of men, the rules of proper behavior were the great point; in their regulation of those rules of propriety, reverence was the great point." (古之為政，愛人為大；所以治愛人，禮為大；所以治禮，敬為大。)[6]

The expression of love, both physically or through words and images, must be confined within the rules of propriety and abide by the appropriate act of reverence in the Confucian-oriented society. Confucius further points out: "Thus it is that gentlemen commence with reverence as the basis of love. To neglect reverence is to leave affection unprovided for. Without loving there can be no real union; and without reverence the love will not be correct. Yes, love and reverence lie at the foundation of government!" (是故，君子興敬為親，舍敬，是遺親也。　弗愛不親；弗敬不正。愛與敬，其政之本與！)[7] Any overly demonstrative effusion of love would violate the notion of reverence and was therefore not encouraged in traditional China. Under such influence of Confucian decorum, men and women in love could not touch each other's hands even if they needed to pass over objects.[8] And married people should treat their spouses with reverence as if they were guests.[9]

According to the Confucian teachings, the act of reverence should be made not only to the living beings but also to the spirits of the dead. Confucius believed that people ought to "perform their duties as civilians, and to keep aloof with reverence from ghosts and deities is what understanding is really all about." (務民之義，敬鬼神而遠之，可謂知矣。)[10] The great philosopher's concern was mainly with issues ethical rather than metaphysical or supernatural; therefore he avoided questions about death and spiritual beings. His famous statement in the *Lunyu* 論語 (Analects) elicits: "One does not yet know life, how could one know death?" (未知生，焉知死？)[11] This agnostic mindset on death epitomizes the general characteristics of the Confucian tradition which has focused on human society of this world while being indifferent to the issues of death and afterlife.

The reticent approaches of Confucianism to love and death exerted great influence on the visual representation of the related themes, in particular in the early periods when Confucian ethical doctrines were dominant forces in the arts.[12] Even in the literati painting tradition of the Ming and Qing dynasties, Confucianism never lost its grip on the practitioners who were scholar artists principally trained in Confucian teachings. It is without question that traditional Chinese literati painting was excessively focused on landscape, a subject matter colored with Daoist overtones. But in fact the development and prosperity of landscape painting in China was also indebted considerably to the Confucian belief that: "The wise enjoy waters, and the benevolent enjoy mountains." (知者樂水，仁者樂山。)[13] Chinese scholar artists' passion for mountains and waters and their preference for the landscape subject in painting were thus imprinted with Confucian ethical values, as illuminated in the "Preface on Landscape Painting" by the 5th-century art critic Zong Bing 宗炳 (375-443).[14] In a typical Chinese literati painting, the rendering of an idealized landscape of seclusion suggests a harmonious relationship between man and nature, and the presence of human beings

is always minimal in the vastness of nature. For the Chinese scholar artists, a landscape painting not only could nurture their virtues, but could offer them a refuge from their everyday life where worldly matters, including the mundane concerns of love and death, seem to become trivial and irrelevant.[15] The emphasis of these ethical and spiritual aspects has led to the impression that Chinese landscape painting, or even Chinese art in general, is aloof to such earthly issues of human concerns like love and death.

Added to this is the fact that there are rarely any discussions and remarks pertaining to love and death in the myriads of books and essays on the function and meaning of art throughout the centuries in China.[16] It would nevertheless be imprudent to assume that traditional Chinese art is deficient in representing these two important themes. In fact Chinese artists have been constantly motivated and inspired by the emotional and philosophical richness of the themes of love and death, but in the past they were inclined to render them in considerably indirect and subtle ways using symbolic visual images and literary allusions. The unique treatment of these themes in Chinese painting, which demonstrates strong Confucian influence and constraints, poses a challenge to modern viewers or even experienced and well-trained art historians in deciphering the coded messages.

There are however certain areas of folk and religious art in traditional China in which Buddhist and Daoist customs and beliefs were evidently more significant than Confucianism, and thus love and death became the central themes whose renderings are more direct and implicit. For instance, death played a major role in liturgical and funerary art as evidenced from temple murals to burial furnishings, and the depictions of love stories and scenes, such as the illustrations for romance novels and the erotic images in pillow books, were popular during the Ming and Qing periods.[17] These artifacts and art forms, although not considered sophisticated enough for serious aesthetic discussions by traditional Confucian-educated gentlemen, provide a rich source of visual materials that can help unveil the mysteries of the symbolism of love and death in Chinese painting.

The appreciation and collection of burial objects has a long history in China. Related studies and publications were highly developed in the Qing Dynasty, but the scholarly attention was principally devoted to the ancient inscriptions on various funerary vessels or steles that pertain to the fields of linguistics and epigraphy.[18] Broader researches on ancient tombs and their burials were conducted in the 20th century from philosophical to archaeological to art historical approaches which have strengthened our knowledge of the religious beliefs and philosophical concepts of the Chinese view of death. Michael Loewe, in particular, embarked on the iconographic investigation of certain funerary furnishings which probes into the different social, political, religious and cultural contexts of Han China regarding death and the afterlife.[19] Recent books by Wu Hung and Wang Deyu furthered art historical scholarship of the topic with their focus again on the early periods.[20] In the field of Chinese literati painting, Kiyohiko Munakata and Jerome Silbergeld both touched upon the issues surrounding old age, death and immortality in their studies, but more specific and in-depth consideration is needed to fill the gap in understanding the subtle use of symbolic and allusive images of death in the traditional elite culture.[21]

The scholarship of love in Chinese art also gained momentum during the second half of the 20th century. Robert Hans van Gulik pioneered the research on romantic love, delving into the sexual practice and culture in traditional China with references to both literature and pictorial art. His publication on the Ming erotic prints and the survey of sexual life in ancient China opened the window on this previously little researched field.[22]

Some Chinese art historians were drawn to the intriguing visual representations of love, but their studies center almost exclusively on the narratives of the artworks that are associated with historical and folk sources. Wang Yaoting, for instance, examined the paintings using their inscriptions to reference the romances in Chinese literature and poetry.[23] Ellen Johnston Laing's article also relates the "Beautiful Woman" genre in Chinese painting to the love verses known as "Palace-Style" poetry.[24] A growing body of scholarly inquiry on the subject was generated in recent years, among which the essay by Jan Stuart strives to incorporate iconographic analysis into her discussion, envisaging a new dimension in the study of the hidden symbols of love.[25]

As opposed to the scarcity of traditional writings on visual arts about love and death, Chinese literature has attracted a wealth of scholarship addressed to these two themes throughout the centuries. In his celebrated *Wenfu* 文賦 (Rhapsody on Literature), the Western Jin critic Lu Ji 陸機 (261-303) puts forward the aesthetic criterion: "Beauty of poems comes from emotions." (詩緣情而綺靡。)[26] Lu Ji's critical remark sums up a strong literary tradition in China that stresses emotional expressions rather than the more Confucian view of "poems expressing ideals" (詩言志).[27] Love and death are the basic human emotions that have always been embraced by Chinese writers and poets.[28] In the *Shijing* 詩經 (Book of Songs), the earliest existing collection of poems, these two themes are treated extensively with rich and subtle use of metaphors, allegories and symbols. A pair of mandarin ducks first appeared in the *Shijing* and became one of the best-known symbols for a blissful couple.[29] Other birds like the wooing ospreys are employed as metaphors to suggest men and women in love.[30] References to death are also prevalent in the ancient poems, in which yellowed plants and ephemerae refer to the perished and the transience of life.[31]

Many of the literary metaphors, allegories and symbols, like those meaning-laden plants, insects, birds and animals in the *Shijing*, provide a corpus of allusion sources for pictorial representation and contextualization in the visual arts. The shared application and significance of the richly nuanced images became characteristics of the Chinese literati painting tradition, in which scholar artists were privileged with the literary training to invest their works with deeper and more sophisticated meanings. One of the most outstanding examples is the symbolism of bamboo. The plant was charged with the qualities of a gentleman in the ancient poems and has since served as a popular subject in Chinese painting to bespeak one's nobility, tenacity and uprightness.[32]

There is a panoply of literary-inspired imagery and other iconographic elements in Chinese paintings that are suggestive of love and death. But these allusive and symbolic images were created, cultivated and circulated among elite members of the aristocracy of letters in traditional China. Many of them have become inaccessible to modern viewers, and thus are still not considered associated with the themes of love and death. This exhibition will be the first ever devoted to these two themes in Chinese art. A selection of Ming and Qing paintings is drawn from the prominent Roy and Marilyn Papp Collection in Phoenix to illuminate their rich and complex visual representations of love and death. By employing a method combining iconographic analysis and literary examination, these essays intend to explore and uncover the underlying and hidden meanings of the related metaphors, allegories and symbols.

Notes to Introduction

Translations are by the author unless otherwise noted.

1 Chen Zhongfu 陳仲甫 (Duxiu), "Preface to *The Crimson Gauze*," in *The Complete Work of Su Manshu* vol. 4 (Shanghai: Beixin Shuju, 1933), 46-47.

2 Freud argued that humans' natural instincts or drives of love (Eros) and death (Thanatos) both coincide and conflict within the individual and among individuals. Sigmund Freud, *Civilization and Its Discontents*, trans. by James Strachey (New York: Norton, 1961), 70-82.
The exhibition entitled *Eros & Thanatos - Drives, Images, Interpretations* showcasing Western artworks related to the themes of love and death was held at the Sigmund Freud Museum and Liechtenstein Museum in Vienna in 2009.

3 See, for example: *Images of Love and Death in Late Medieval and Renaissance Art*, essays by Clifton C. Olds and Ralph G. Williams, catalog by William R. Levin (Ann Arbor: University of Michigan, Museum of Art, 1976); Angus Trumble, *Love & Death: Art in the Age of Queen Victoria* (Adelaide: Art Gallery of South Australia, 2001); Elena Santiago, *On Love and Death: Drawings and Engravings in the Biblioteca Nacional* (Barcelona: Fundació Caixa de Catalunya, 2001); *Love Everlasting: The Art of Romance Through the Millennia*, co-curated by Raymond J. Kelly III & Kristie Everett (Flint Institute of Arts, January 29– March 19, 2000); *Art's Lament: Creativity in the Face of Death*, curated by Hilliard T. Goldfarb (Boston: Isabella Stewart Gardner Museum, 1994); *Images of Death in Contemporary Art* (Milwaukee: The Patrick and Beatrice Haggerty Museum of Art, Marquette University, c1990); *Memento Mori : Der Tod als Thema der Kuns vom Mittelalter bis zur Gegenwart*, catalog by Klaus Wolbert (Darmstadt: Hessischen Landesmuseum, 1984 bis 28.10.1984).

4 Confucius once said: "Look not at what is contrary to propriety; listen not to what is contrary to propriety; speak not what is contrary to propriety; make no movement which is contrary to propriety."
(非禮勿視，非禮勿聽，非禮勿言，非禮勿動。) Zhu Xi 朱熹 (1130-1200) annot., *Sishu zhangju jizhu. Lunyu jizhu* 四書章句集注·論語集注 (Collected Annotations on the Four Books. Collected Annotations on the Analects) (*Siku quanshu* 四庫全書, hereafter *SKQS*) *juan* 6 (Shanghai: Shanghai Guji Chubanshe, 1987), 10b.

5 Confucius further elaborated the notion of *jing* in the *Liji*: "In ancient times, under the ruling of the intelligent kings of the three dynasties, it was required (of a man) to show reverence to his wife and son. When the path (of right government) was pursued, the wife was the hostess of the (deceased) parents. Could any husband dare not to show her reverence? And the son was the descendant of those parents. Could any father dare

not to show him reverence? The superior man's reverence is universal. Wherein it appears the greatest is in his reverence for himself. He is in his person a branch from his parents. Can any son but have this self-reverence? If he is not able to respect his own person, he is wounding his parents. If he wounds his parents, he is wounding his own root; and when the root is wounded, the branches will follow it in its dying."
(昔三代明王之政，必敬其妻子也，有道。妻也者，親之主也，敢不敬與？子也者，親之後也，敢不敬與？君子無不敬也，敬身為大。身也者，親之枝也，敢不敬與？不能敬其身，是傷其親；傷其親，是傷其本；傷其本，枝從而亡。) Kong Yinda 孔穎達 (574-648) annot., *Li ji zhushu* 禮記注疏 (Annotations on the *Book of Rites*) (*SKQS*), *juan* 50, 12a-12b.

6 *Li ji zhushu, juan* 50, 12a.

7 Ibid., 12a-12b.

8 In the Mencius, it says: "Men and women do not pass objects through their hands, this is the rule of propriety." (男女授受不親，禮也。) Zhu Xi annot., *Sishu zhangju jizhu. Mengzi jizhu* 四書章句集注·孟子集注 (Collected Annotations on the *Four Books*. Collected Annotations on the *Mencius*), *juan* 4, 11a-11b.

9 The notion and practice of "Paying reverence to one's spouse like a guest" (相敬如賓) is based on the Confucian teaching of reverence. In the *Li ji*, it says: "Based on the governance in the past three generations of brilliant kings, they have always respected their wives. Their sons also have Tao. Wife also has Tao. She is the figurehead of a family. You dare not to respect her? (昔三代明王之政，必敬其妻、子也有道。妻也者，親之主也，敢不敬與？) *Li ji zhushu, juan* 50, 13b.

10 *Lunyu, juan* 3, 15b. Confucius's avoidance of talking about death and spiritual beings can also be seen in the *Lunyu*: "master (Confucius) did not talk about things strange, miraculous, paranormal, (including) spiritual beings." (子不語怪，力，亂，神。) *Lunyu jizhu, juan* 4, 6a.

11 *Lunyu jizhu, juan* 6, 3a.
(論語，先進第十一)

12 James Cahill, "Confucian Elements in the Theory of Painting," in Arthur F. Wright ed., *Confucian Persuasion* (Stanford: Stanford University Press, 1960), 115-140.

13 *Lunyu jizhu, juan* 3, 16a. The Chinese word for landscape or landscape painting is *shanshui* 山水, which literally means "mountains and waters."

14 Zong Bing wrote: "Now, sages follow the Dao through their spirits, and the virtuous comprehend this. Landscapes display the beauty of the Dao through their forms, and humane men delight in this. Are these not similar?" (夫聖人以神法道，而賢者通；山水以形媚道，而仁者樂。不亦幾乎？) Translations from Susan Bush and Hsio-yen Shih, *Early Chinese Texts on Painting* (Cambridge: Harvard University Press, 1985), 36.

15 The Northern Song painter Guo Xi 郭熙 (circa.1023-circa.1085) explored the Confucian ethical concept of landscape: "Why does a virtuous man take delight in landscapes? It is for these reasons: that in a rustic retreat he may nourish his nature; that amid the carefree play of streams and rocks, he may take delight; that he may constantly meet in the country fishermen, wood-cutters, and hermits, and see the soaring of the cranes, and hear the crying of the monkeys. The din of the dusty world and the locked-in-ness of human habitations are what human nature habitually abhors..." (君子之所以愛夫山水者，其旨安在？丘園，養素所常處也；泉石，嘯傲所常樂也；漁樵，隱逸所常適也；猿鶴，飛鳴所常親也。塵囂韁鎖，此人情所常厭...) Translation from Shio Sakanishi, *An Essay on Landscape Painting* (London: John Murray, 1935), 30.

16 For instance, Zhang Yanyuan 張彥遠 (815-907), the great Tang art historian, conforms to Confucian learning in defining the function of painting. He said: "Painting is a thing to perfect the civilization, to aid human relations, to reveal infinite changes, and to fathom the subtle." (夫畫者，成教化，助人倫...) Zhang Yanyuan, *Lidai minghua ji* 歷代名畫記 (Records of Famous Paintings of Successive Dynasties) (*SKQS*), juan 1, 1a.

17 See, for instance, Michel Beurdeley, *Chinese Erotic Art*, trans. Diana Imber (Rutland & Tokyo: Charles E. Tuttle, 1969); Abraham N Franzblau, *Erotic Art of China: A Unique Collection of Chinese Prints and Poems Devoted to the Art of Love* (New York: Crown Publishers, 1977) and Ferdinand M. Bertholet, *Gardens of Pleasure: Eroticism and Art in China* (Munich: Prestel, 2003).

18 The studies and publications can be found as early as in the Northern Song period and the scholarship became popular in the Qing Dynasty.

19 Michael Loewe *Ways to Paradise: The Chinese Quest for Immortality* (London : G. Allen & Unwin, 1979); *Chinese Ideas of Life and Death: Faith, Myth and Reason in the Han Period (202 BC–AD 220)* (London, Boston: Allen & Unwin, 1982).

20 Wu Hung, *The Art of the Yellow Springs: Understanding Chinese Tombs* (Hawaii: University of Hawaii Press, 2010); Wang Deyu, *Life and Death in Early Chinese Art* (Taipei: National Museum of History, 2000.)

21 Kiyohiko Munakata, "Chinese Literati and Taoist Fantasy: Case of Shen Chou and Wu School Artists," paper presented at the College Art Association annual meeting (New York, February 1986); Jerome Silbergeld, "Chinese Concepts of Old Age and Their Role in Chinese Painting, Painting Theory, and Criticism," *Art Journal* 46.2 (Summer 1987): 103-114.

22 Robert Hans van Gulik, *Erotic Colour Prints of Ming Period*: *With an Essay on Chinese Sex Life from the Han to the Ch'ing Dynasty, B.C. 206-A.D. 1644* (Leiden: Koninklijke Brill NV, 2004, first published 1951). See also, *Sexual Life in Ancient China; A Preliminary Survey of Chinese Sex and Society from ca. 1500 B.C. Till 1644 A.D.* (Leiden: E. J. Brill, 1961).

23 Wang Yaoting, "Images of the Heart: Chinese Paintings on a Theme of Love," *National Palace Museum Bulletin* 22.5 (November/December, 1988): 1-21; 22.6 (January/February, 1988): 1-21.

24 Ellen Johnston Laing, "Chinese Palace-Style Poetry and the Depiction of a Palace Beauty," *The Art Bulletin* 72.2 (June, 1990): 284-295, and "Erotic Themes and Romantic Heroines Depicted by Ch'iu Ying," *Archives of Asian Art* 49 (1996): 68-91.

25 Jan Stuart focuses in particular on the images associated with the *Xixiang ji* 西廂記 (Story of the West Wing), arguably the best known love story in China. Jan Stuart, "Two Birds with the Wings of One: Revealing the Romance in Chinese Art," in Karen Sagstetter ed., *Love in Asian Art & Culture* (Washington D.C.: Arthur M. Sackler Gallery, 1998), 11-29.

26 Lu Ji, *Lu Shiheng wenji* 陸士衡文集 (Collected Works of Lu Shiheng) (*Sibu congkan*), juan 1, 3a. But it is oddly enough that when Lu Ji's critical attention turned to painting, he adopted a different view which values the Confucian ethical values. This difference may suggest the basic difference in attitudes towards art and literature. Lu Ji, as quoted in Zhang Yanyuan's *Lida minghua ji*, states: "The rise of painting, like the composition of the *ya* (odes) and *song* (hymns), is to glorify the great cause of moral and social amelioration." (丹青之興，比《雅》、《頌》之述作，美大業之馨香。) *Zhang, Lidai minghua ji, juan* 1, 2b.

27 The Confucian influence on the exegesis of poetry can be seen in the "Great Preface" to the *Shijing*: "Poems are, where the ideals aim at." (詩者，志之所之也。) See Kong Yingda annot., *Maoshi zhushu* 毛詩注疏 (Annotations on the *Shijing*), juan 1, 3a.

28 Wang Yaoting also noticed the difference in the representations of emotions in Chinese art and literature, stating: "Emotions can be expressed through any of several kinds of media – words, sounds, and images – but the educational background of most people is such that they consider words to be the most fundamental of these, and so emotions tend to become manifested as poetry and prose. If they are to be manifested as paintings, the artist must construct his compositions as carefully as the poet constructs his lines, and he must undergo a certain amount of training before he is able to express himself at will. Yet one does not see this even in the works of such famous personalities as Chao Meng-fu and Kuan Chung-chi, let alone in the works of others." See Wang Yaoting, "Images of the Heart" *National Palace Museum Bulletin* 22.6.10.

29 In the *Shijing,* the poem "Mandarin Ducks" reads: "The Mandarin ducks fly about, and are taken with hand-nets and spread-nets. May our sovereign live for ten thousand years, enjoying the happiness and wealth which are his due !" (鴛鴦于飛,畢之羅之。君子萬年,福祿宜之。) *Kong, Maoshi zhushu, juan* 21, 39a.

30 The poem "Wooing Ospreys" writes: "Guan, guan, the ospreys woo to their mate; that coos on the river air. Fair and gracious maiden; well matched for courting gentlemen." (關關雎鳩,在河之洲。窈窕淑女,君子好逑。) *Maoshi zhushu, juan* 14, 24a-24b.

31 The poem "Every Plant Turns Yellow" reads: "Every plant turns yellow; everyday we march… Every plant turns black; every man is torn from his wife." (何草不黃,何日不行…何草不玄 ,何人不矜。) Another

poem "The Ephemera" reads: "The ephemera's wings like morning robes are bright. My heart is grieved, would they but come and rest with me?" (蜉蝣之翼,采采衣服。心之憂矣,於我歸息。) *Maoshi zhushu, juan* 22, 71b-72a; *juan* 14, 2b.

32 The poem "The Bank of the River Qi" reads: "Behold the bank of the River Qi. The undulant bamboo forest dances. A handsome man, intently working, as a great master sculpting a piece of jade, as a great artist carving a piece of ivory. Relaxed, confident, dignified and stately… Such an elegant man! How can I ever forget him?" (瞻彼淇奧,綠竹猗猗。有匪君子,如切如磋,如琢如磨,瑟兮僩兮,赫兮咺兮。有匪君子,終不可諼兮。) *Maoshi zhushu, juan* 5, 2a-2b.

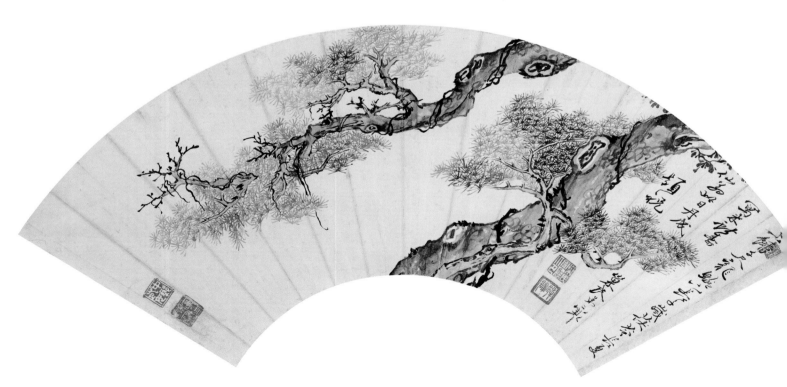

1 Mao Xiang 冒襄 (1611 – 1693) and Cai Han (1647 – 1684)

Introduction

Hidden Meanings of Love

Love is represented in Chinese paintings most commonly through visual images with literary allusions. Many kinds of plants, insects, birds and animals were encoded with subtle and profound meanings of love in ancient literature because their physical characteristics and life habits could resonate with human emotions and experience.[1] These images were later adopted by Chinese painters to enrich their visual repertoire of the theme. One of the frequently used subjects is the pairing of *niao* 蔦 (*Viscum*) or *nuluo* 女蘿 (*Cuscuta*) with pine or cypress, but interestingly enough their symbolism in painting has been little noticed and researched. The underlying import of the relationship between the parasitic plants and the host trees was first coined in the *Shijing*, which says: "*Niao* and *nuluo* are growing over the pine and cypress. While not seeing you, oh darling, all in my heart is nothing but sad. When I do see you, I shall be gay and glad." (蔦與女蘿，施于松柏。未見君子，憂心奕奕。既見君子，庶幾說懌。)[2]

In the Roy and Marilyn Papp collection, there is an intriguing fan painting [1] executed by the late Ming and early Qing literatus Mao Xiang 冒襄 (1611-1693) and his concubine Cai Han 蔡含 (1647-1684).[3] The elegantly posed pine tree was painted by the gifted concubine while the inscription on the right was written by her husband. According to the poetic inscription, the painting was given by Mao Xiang to one of his friends as a birthday gift:

上蟠千尺龍鱗，	Above, a thousand feet of dragon scales twine around,
下長千歲茯苓。	And below, there lives *fuling (Poria coccus)* of a millennium.
長夏寫來獻壽，	Writing this in the summer to celebrate the birthday
仙翁此日丹成。	Of the immortal old man, who successfully made the elixir today.

The pine tree seems to be an obvious symbol of long life appropriate for birthday blessings. But there is a hidden meaning veiled behind the simple and lucid composition, in which the depiction of an almost imperceptible climbing plant entwined around the trunk and branches of the tree in fact suggests an underlying message about love.

The climbing plant refers to *nuluo*, a kind of parasitic dodder that lacks leaves and roots but has special suckers for drawing nourishment from its host. *Nuluo* has long been used as a symbol of love in Chinese literature to allude to an affectionate and attached couple. The plant's parasitic nature vividly evokes the inseparable bond and attachment between lovers. In one of the *Gushi shijiu shou* 古詩十九首 (Nineteen Ancient Poems) of the Han dynasty, it says: "Me and my dear, newly married, are attached to each other like *tusi* (dodder) and *nuluo*." (與君為新婚，菟絲附女蘿。)[4] The symbolism of the plant also sees its equivalent in the West, earning itself the folk name of "love vine."

Cai Han's depiction of *nuluo* and the pine tree also makes a literary allusion to *si luo fu qiaomu* (絲蘿附喬木), which means "(*Tu*)*si* and (*nu*)*luo* are dependent on tall trees." The "Biography of the Dragon-Beard Man" by Du Guangting 杜光庭 (850-933) of the Tang dynasty recounts the romance of the prominent general Li Jing 李靖 (571-649) and the courtesan Hongfu Nu 紅拂女. When Hongfu Nu declared her love to Li Jing, she said: "(*Tu*)*si* and (*nu*)*luo* cannot live by themselves, they want to rely on tall trees. So I ran away and came here." (絲蘿非獨生，願托喬木，故來奔耳。) It is evident that Cai Han painted herself as the leafless and rootless *nuluo* twining itself around the pine tree to express in a timid and tender way her love and attachment to her husband. The embodiment of herself as the parasitic dodder can be further substantiated by her *zi* 字 (literary name), which is *nuluo*, the same as the plant's name.[5] But Cai Han's message of love is so indirect and subtle that apparently her husband failed to notice it and thus gave the painting away to his friend.

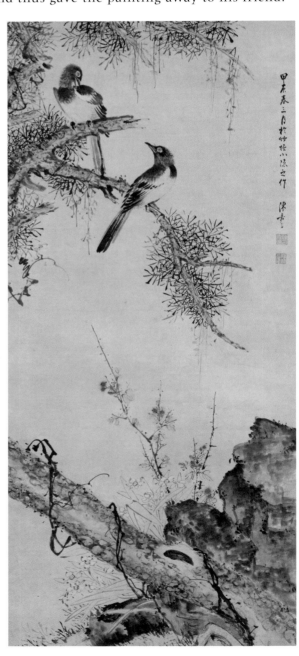

Nuluo and the pine tree appear again in a painting in the Papp collection by the early Qing artist Chen Jiayan 陳嘉言 (1599-after 1678) [2]. In addition to the symbolism of the plants, which allude to an affectionate couple, the theme of love is reinforced by the two birds perching on the branches while looking tenderly at each other. The pair of birds in the painting refers to the so-called *shuangqi qin* 雙棲禽 (two perching birds), a literary metaphor of a beloved couple living a happy marriage.[6] A well-known painting attributed to the Song emperor Huizong 徽宗 (r. 1100-1126) in the National Palace Museum in Taipei applies skillfully the literary metaphor by rendering two white-headed birds resting closely together on a branch of wintersweet. The poetic inscription by the emperor manifests the promise of love to "live a thousand autumns and become white-headed together." (千秋指白頭。)[7]

The birds depicted in Chen Jiayan's painting are magpies, which the Chinese call *xique* 喜鵲, literally meaning "happy magpies." It is believed in China that when people hear the magpie sing, something joyful and celebratory will happen.[8] Hence the bird has become a propitious emblem bespeaking happiness and good luck.

2 Chen Jiayan 陳嘉言 (1599 – after 1679)

Hidden Meanings of Love

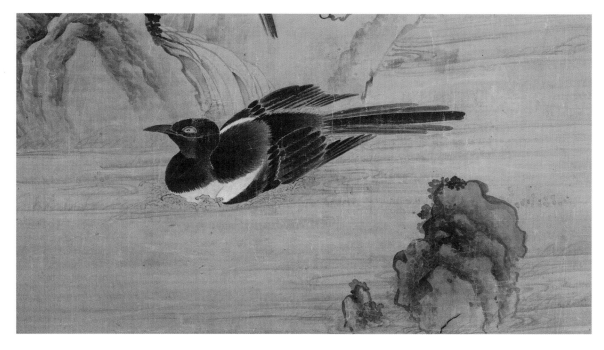

3 Tong Yuan 童原 (active 17th C.) Detail — full view on page 43

It also implies particularly the joy and bliss of love. The famous folk legend about Niulang 牛郎 and Zhinu 織女, the Herd-boy and Weaving-girl, tells that the two lovers are separated by the Milky Way as a punishment for angering the Emperor of Heaven.[9] They are permitted to meet only once a year on the seventh day of the seventh lunar month when magpies form a bridge for them to pass over the barrier. The date that the lovers meet became the Chinese Valentine's Day, and the magpies came to symbolize a happy marriage.

Magpies are often shown in pairs in Chinese art, which forms the metaphor of *shuangxi* 雙喜, or "happiness for two". This auspicious idea is best seen in the creation of the ligature *xi* 囍 to indicate ideogrammatically "a happy pair." It is therefore specifically used to denote a blissful conjugal love, and in particular as a blessing on the occasion of nuptials. Decorations with the ligature can be found all over a traditional wedding ceremony, and the most striking is the application of red paper-cuts on the windows of the bridal chamber. The paper-cuts are frequently designed with the ligature and two magpies, both designating the idea of "a happy pair."[10] Chen Jiayan's rendering of the pine and the parasitic plant *nuluo*, together with the two magpies, thus strengthen the message of love and happy marriage.

As a popular subject matter in Chinese art, the magpie is represented in another painting in the Papp collection by Tong Yuan 童原 (active 17th C.) of the late Ming and early Qing periods [3]. The painting demonstrates a dynamic composition with a flock of magpies, a few twisted pine branches and some river stones forming an S-curve. Despite a similar selection of visual images in Tong Yuan and Chen Jiayan's works, the messages that they convey through their delineations of the bird and tree are quite different. Tong Yuan's pine branches are free of any parasitic dodder and he depicts four magpies perching separately instead of grouping two in pairs like Chen Jiayan. The painting most likely has no such meaning as love. It otherwise signifies a wish for happiness and long life by employing the two common symbols.

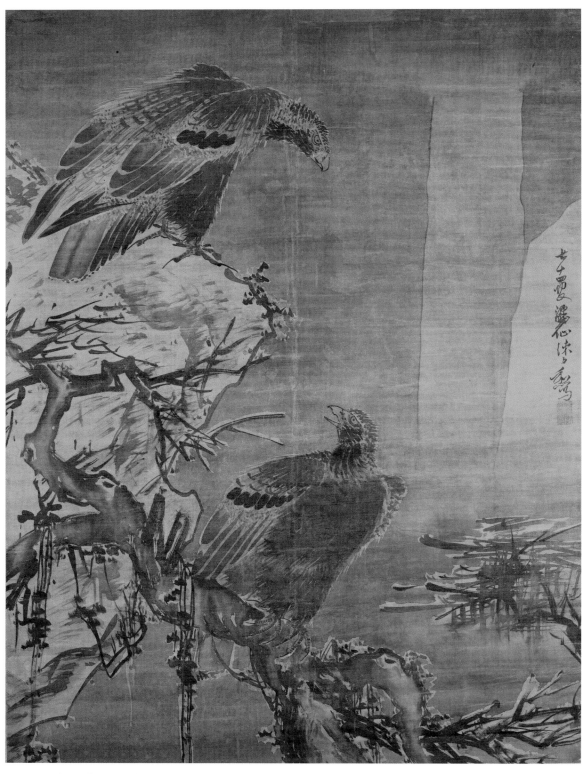

4 Chen Zihe 陳子和 (fl. late 15th – early 16th C.)

There are a number of paintings in the Papp collection which are imbued with subtle meanings of love and happy marriage. A large composition depicting two eagles by the Ming artist Chen Zihe 陳子和 (active early-mid 16th C.) [4] again shows the parasitic dodder entwined around the pine, symbolizing conjugal affection. The two birds, which allude to *shuangqi qin*, stand for a beloved couple. Bending and turning their heads, they exchange gazes while twittering to each other. Since the eagle is the strongest and lives the longest among birds, it has been regarded as a symbol of power and longevity in Chinese culture.[11] A traditional artwork using these symbolic bird and plant images would serve perfectly as a gift for an aged couple to wish them good health and long life.

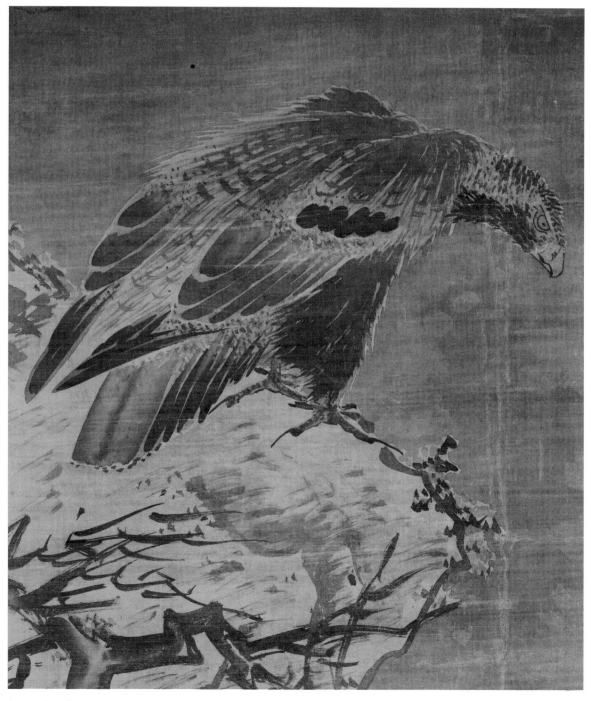

4 Detail

A painting of a similar subject matter and content by the Qing female artist Wang Zheng 王正 (active late 17th – early 18th C.) displays a more elaborate style with meticulously executed images of birds and flowers [5]. The artist's inscription gives a poetic description of the images: "In the crabapple white-headed starlings talk among themselves; among the rocks pheasants sing while flowing water sounds." (棠上白頭翁自語，石間雉唱雜泉聲。)[12] At the center of the painting, a brightly-colored male pheasant perches on the top of a perforated rock with peonies at the back, looking down to its female partner. The symbolism of conjugal love is recapitulated by the two white-headed birds high up on the flowering crabapple tree. The crabapple, with its clustered blossoms, has been praised like peonies as the "flower of wealth and nobility."[13] These two plants form the good wish of *mantang fugui* 滿堂富貴 (entire family of wealth and nobility), thus adding to Wang Zheng's painting an additional meaning of auspiciousness.[14]

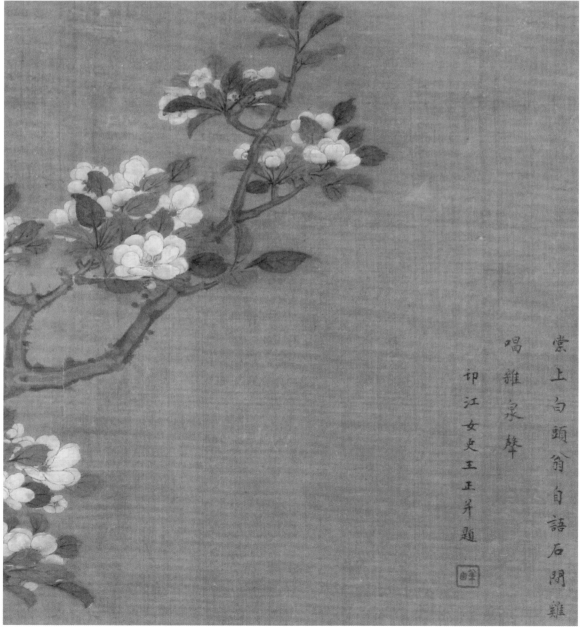

5 Detail

Hidden Meanings of Love

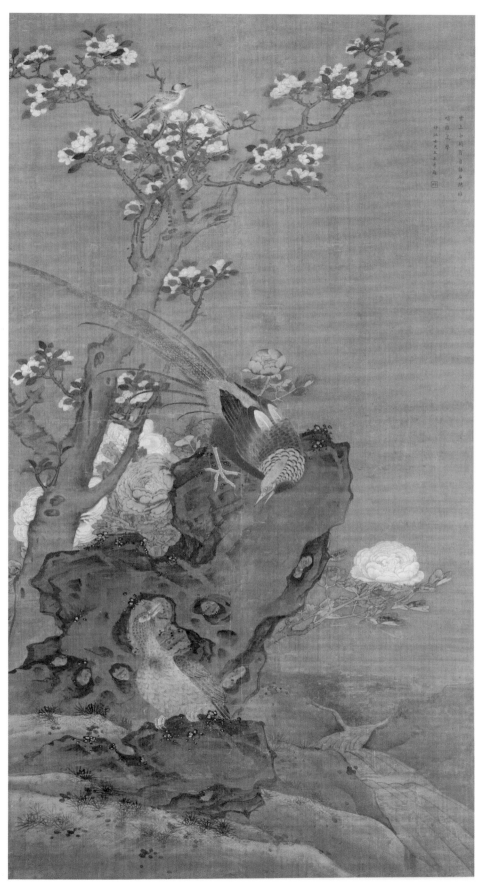

5 Wang Zheng 王正 (fl. late 17th – early 18th C.)

Romantic love, due to the privacy and intimacy of its nature, has been treated in Chinese painting more often, and more fittingly, through small and portable formats like fans or albums. Such an album piece by the prominent Qing bird-and-flower painter Shen Quan 沈銓 (1682 – ca. 1760) can be found in the Papp collection. It displays a rich variety of imagery with literary-related symbols of love. One of the leaves from the album depicts a pair of cranes resting closely on a pine tree [6]. The images are conventionally known for their symbolism of longevity, but they also make references to *shuangqi qin* and *si luo fu qiaomu*. Shen Quan ingeniously places the two perched cranes on a gnarled pine tree, on which a climbing parasitic plant is growing and twining itself around its truck and branches. The two birds are also elaborately posed in a *jiaojing* 交頸 (crossed necks) position to further accentuate the message of love. As a pictorial counterpart of the poetic lines: "A pair of birds are perching up there, crossing their necks while singing harmoniously" (上有雙棲鳥，交頸鳴相和。), the album leaf vividly expresses the wish for a long life and lasting love.[15]

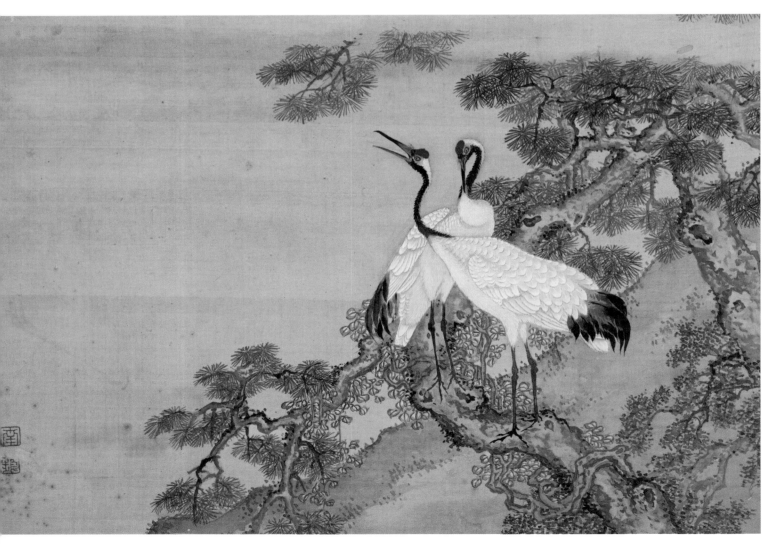

6 Shen Quan 沈銓 (1682- ca. 1760)

Hidden Meanings of Love

A different leaf from Shen Quan's album illustrates the same love theme as well as the auspicious implications [7]. With regard to the subject matter, the cranes are substituted with two spotted deer, another common animal symbol of longevity and prosperity in Chinese culture.[16] Along a tiny brook in the painting, an antler-bearing hart is striking forward towards its female partner, which is kneeling in a resting posture. Not only do they embody a happy and blessed couple, but their poses reflect the Confucian decorum that promotes the ideal marital relationship of women's subordination to men's authority. A more tender sentiment of love is indicated by the two cypress trees next to the hind. The trees, with their trunks crossed and joined together, form the so-called *lianli shu* 連理樹 (interlocked trees). *Lianli shu* is one of the best-known metaphors in Chinese literature that signifies the conjugal union.[17] The famous canto entitled *Song of Everlasting Regret* by the Tang poet Bai Juyi 白居易 (772-846) made powerful use of the metaphor: "I wish we were two birds in the sky flying side by side, and I wish we were two *lianli* trees on the earth inseparably tied." (在天願作比翼鳥，在地願為連理枝。)[18] Shen Quan's masterful design and execution echo the poetic lines in suggesting a wish for long-lasting, unchangeable and inseparable love.

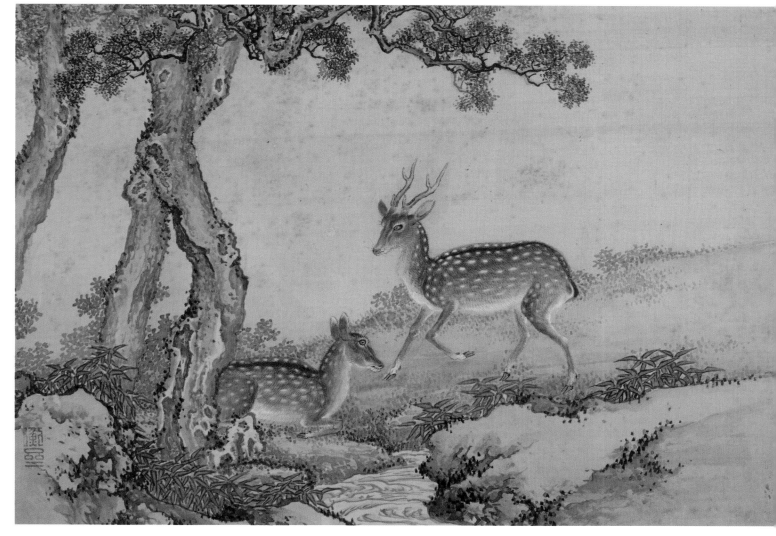

7 Shen Quan 沈銓

The love theme is presented in yet another leaf from the same album, in which the subject matter is changed to two monkeys [8]. These playful animals amuse themselves on a twisted truck of a pomegranate tree that leans over a waterfall. Besides the monkeys, images like the flying bees, the pomegranate fruits and the streams of waterfall are all shown in pairs to connote a happily married couple. But there are other meanings hidden in the seemingly simple composition. Shen Quan skillfully used puns to bestow a good wish for success in an official career. The Chinese word for monkey is *hou* 猴 which is homophonous depiction of the monkeys playing with the bees therefore forms the rebus for *fenghou* 封侯, suggesting "May you be conferred the rank of marquis." Furthermore, the pomegranate tree, with its fruits full of red seeds and juice, has been a symbol of fertility and prosperity in China, thus conveying a blessing for ample progeny.[19]

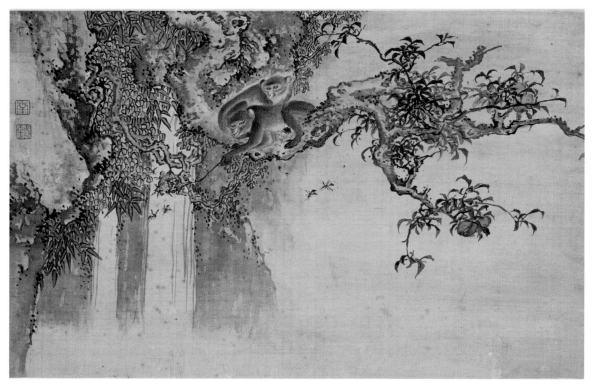

8 Shen Quan 沈銓

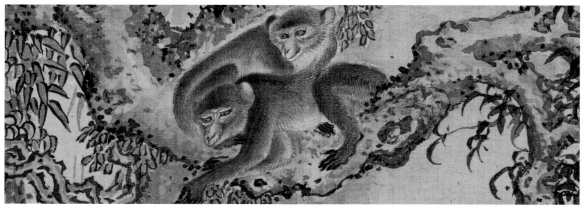

Detail

Hidden Meanings of Love

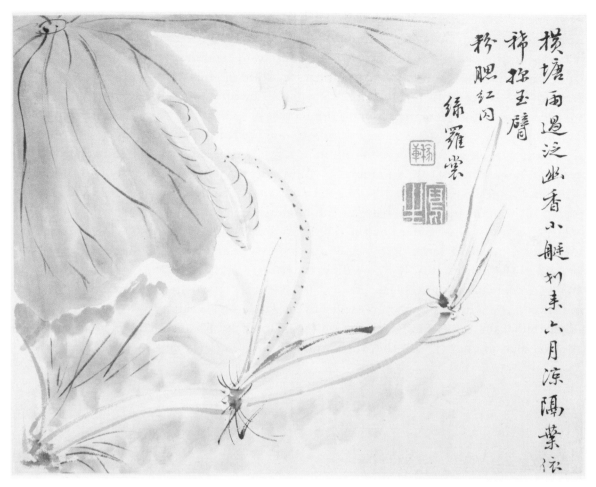

9 Qian Weicheng 錢維城 (1720 – 1772)

The privacy and intimacy of the album format made it a perfect means for visual representation of the theme of love in traditional Chinese painting. Another Qing dynasty album, by the scholar artist Qian Weicheng 錢維城 (1720 – 1772), in the Papp collection also includes several leaves that subtly convey the message of love. One of them addresses the theme with erotic tones in a delicate way [9]. The underlying meaning behind Qian Weicheng's snapshot rendering of a lotus pond is insinuated in his inscribed poem:

橫塘雨過泛幽香，	After the rain, a quiet fragrance suffuses the pond.
小艇划來六月涼。	The passing rowboat carries with it [a light breeze] to cool the summer month.
隔葉依稀掠玉臂，	Beyond the leaves, indistinct, are soft jade arms [linked to one with]
粉腮紅閃綠羅裳。	Fair complexion, red sparkles and a green silk gown.[20]

Lotus has traditionally been devised as a feminine symbol laden with sensual and sexual connotations. A *Yuefu* 樂府 (Music Bureau) poem of the Han period illustrates its symbolism by using the phrase "fish having fun in between lotus leaves" (魚戲蓮葉間) as a metaphor of making love, in which fish and lotus leaves stand for the courting men and women.[21] Despite the absence of the fish in the painting, a tender shoot of lotus rhizome under the leaves alone features strong sensual undertones.

The rhizome, which grows underwater in the mud in nature, is now exposed in the air. Its node and surface color, as indicated in the poetic lines, refers to a woman's naked arm and soft rosy skin, thus creating sexually arousing fantasies.[22] It was a taboo in Chinese art to represent the nude or partially undressed human body, and the expression of love through the representation of female corporeal beauty was very scarce.[23] But richly nuanced images and metaphors, such as the lotus, have inspired Chinese artists to explore the theme of love and sex with extraordinary sophistication and artfulness.

Qian Weicheng's masterful handling of the love theme is exhibited in another leaf from the same album [10]. A branch of willow cuts diagonally across the painting and a cicada flies under a few osiers. It seems to be a casual depiction of a summer scene, but the artist's inscription provides a hint on the hidden message of love. Qian Weicheng states that the painting was inspired by the poetic lines of Fang Gan 方幹 (809-888).[24] The Tang poet once dedicated a series of love poems to a pretty courtesan, in which he describes her "dancing lithe and gracefully like willow twigs" (妙舞輕盈似柳枝) and "having willow-like slim waist, dancing with lively music beats" (舞柳細腰隨拍輕).[25] Owing to its beauty, suppleness, and frailty, the willow has been regarded as an emblem of woman in China. On the other hand, the cicada refers to a gentleman of great integrity because it stays high up on the tree and feeds on dew.[26] Together the plant and insect imply a fantasy romance.

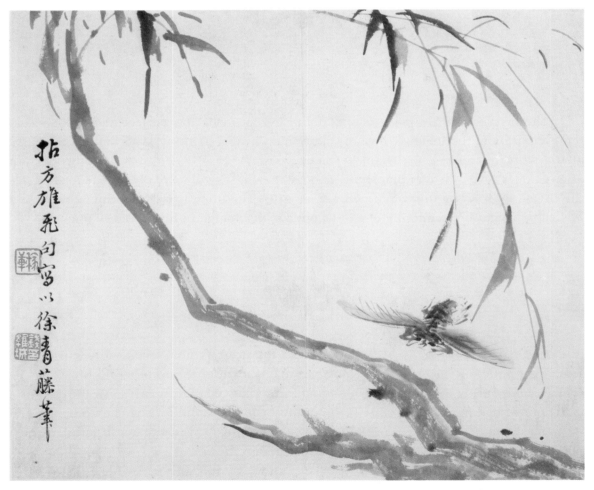

10 Qian Weicheng 錢維城

A third leaf from Qian Weicheng's album delivers the message of love through the so-called "*die lian hua* 蝶戀花" (butterflies in love with flowers) [11]. Similar to the symbols of fish and lotus, butterflies and flowers form the metaphor *die lian hua* that signifies men in love with women. The poetic inscription on the painting, which is in line with the metaphorical meaning, reveals the artist's infatuation with a beautiful lady:

红碎秋牕錦爛鋪， In the autumn window, a spray of red vies with glorious colors everywhere.
石花廣袖醉深扶。 The tipsy pinks, of broad sleeves, require support.
美人莫漫誇纖手， Ah my beauty, do not ever boast your skill (in embroidery)!
繡上羅衣却恐輸。 What you have woven into the silk gauze, I fear, may not bring you a prize.[27]

Flowers have been assigned symbolic values of pretty women since antiquity in various cultures. In the *Shijing*, one of the poems says: "A young peach tree, its flowers aflame with color. The lovely maiden marries, bringing comfort to her new home." (桃之夭夭，灼灼其華。之子于歸，宜其室家。)[28] The writer vividly refers the peach's new sprouts and colorful flowers to the bride's youth and beauty. Numerous Chinese poems have used butterflies and flowers to suggest men's fascination with women.[29] The phrase *die lian hua* was also named as the title of one of the most popular lyric poem patterns, and it became an important theme in Chinese bird-and-flower painting.

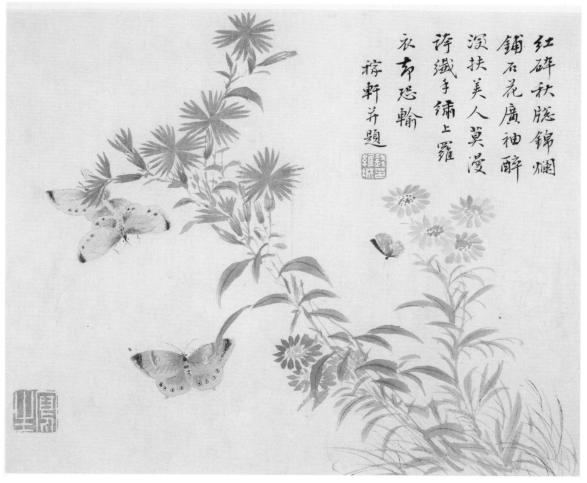

11 Qian Weicheng 錢維城

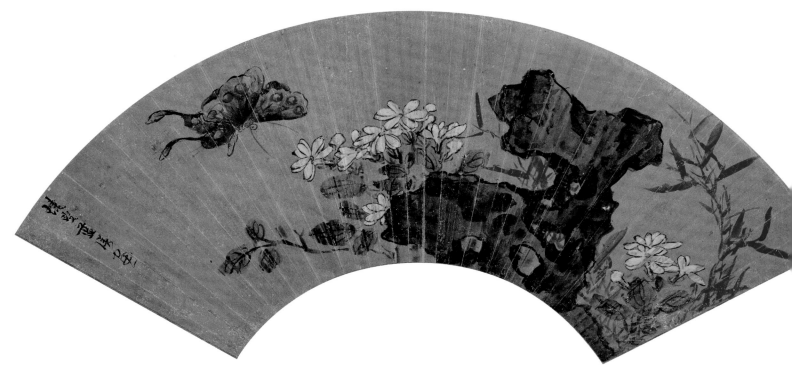

12 Lan Ying 藍瑛 (1585 – 1660)

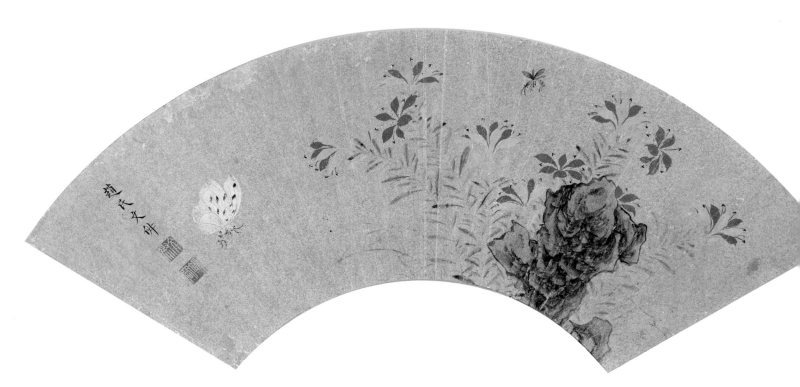

13 Wen Shu 文俶 (1595 – 1634)

Hidden Meanings of Love

For instance, a fan painting by the 17th-century artist Lan Ying 藍瑛 (1585-1660) in the Papp collection elaborately presents the theme of *die lien hua* [12]. A dark-colored swallowtail butterfly with lively red dots on its wings is approaching a cluster of white gardenias, which are grown behind an oddly-shaped Taihu rock along with some red bamboo. In fact Lan Ying painted himself as the butterfly, flirting with the lovely blossoming flowers. The artist's intention is made obvious by the writing of his fancy name *Diesou* 蝶叟 (Butterfly Old Man) on the painting.[30] By applying the metaphor of *die lien hua*, Lan Ying could fantasize himself as a philanderer frivolously enjoying casual romantic liaisons with women.[31] This self-personification perhaps allowed him to find release of a man's suppressed desire from the Confucian moral strictures in the real world.

The theme of *die lien hua* appears again in the fan painting by Wen Shu 文俶 (1595-1634) in the Papp Collection [13]. The late Ming female artist, a contemporary to Lan Ying, adopted a similar compositional arrangement, in which a butterfly on the left is being enticed by the flowers that are scattered behind a rock. Wen Shu utilized the red Morningstar lily to suggest a pretty woman, which attracts the affection of a butterfly as well as a bee. Being a symbol of innocence, purity, chastity and beauty in the West, lily has been given an even more special meaning in China. The flower specifies harmonious and blissful marriage because its Chinese name is *Baihe* 百合, which can stand for the hearty blessing "*bainian hehe* 百年合和*,*"meaning "in harmony and unity for a hundred years".

A number of works by female artists in the Papp collection are associated with the theme of love. Among them, a miniature album leaf painting by Qian Yuling 錢與齡 (fl. mid-18th C.) of the mid-Qing period is of unusual interest [14].[32] Instead of the more common use of symbolic and allusive images, it shows a direct depiction of a love scene where the artist's husband takes her by the hand to enjoy a romantic evening walk in the garden. The sentiment of love is echoed by the two trees growing side by side in front of their humble house. Joined together by their roots on the ground, the trees promise the couple an inseparable binding relationship of love.[33] This personal and intimate painting comes from an album collaborated by Qian Yuling and her husband Kuai Jiazhen 蒯嘉珍 (fl. mid-18th C.), also a renowned scholar artist. It fits perfectly for the format of the small album that was created exclusively and appreciated privately for the couple's own amusement.

14 Kuai Jiazhen 蒯嘉珍 and Qian Yuling 錢与齡 (fl. mid 18th C.) Detail

According to the mid-Qing publication *Yutai huashi* 玉臺畫史 (History of Painting from the Jade Terrace) by the female scholar Tang Shuyu 湯漱玉 (1795-1855), the gifted women artists were either palace ladies, members from prominent families, wives and concubines of famous men or courtesans.[34] Wen Shu, for instance, was a descendent of Wen Zhengming 文徵明 (1470-1559) and daughter of Wen Congjian 文從簡 (1574-1648). Qian Yuling was also born into a prominent family. She was the great granddaughter of the female artist Chen Shu 陳書 (1660-1736) and granddaughter of the renowned official Qian Chenqun 錢陳群 (1686-1774).

Another Qing female painter Dong Wanzhen 董琬貞 (1776-1849) again was from a well-known artist family. She was the granddaughter of the scholar artist Dong Chao 董潮 (1729-1764) and wife of Tang Yifen 湯貽汾 (1778-1853). Her alluring work in the Papp collection, which has a seemingly innocent bird-and-flower subject matter, contains a hidden message of love and devotion [15]. Dong Wanzhen and Tang Yifen are said to have been an affectionate couple, sharing the same interests in poetry, painting, calligraphy and music. The painting by Dong Wanzhen uses plum and bamboo to suggest their devoted love and happy marriage, in which the two plants stand for the couple respectively. Her deliberate pairing of plum and bamboo makes a particular literary allusion to *qingmei zhuma* 青梅竹馬 (green plum and bamboo horse) from a famous poem by Li Bai 李白 (701-762).[35] The meaning of the term is elucidated in the romance play *Kongque dong nan fei* 孔雀東南飛 (Peacocks Fly South East) by Ouyang Yuqian 歐陽予倩 (1889-1962): "You and I already fell in love when young. We were carefree and innocent like the green plum and bamboo horse." (我與你自幼本相愛，青梅竹馬兩無猜。)[36] Based on the biographical evidence, especially the fact that Dong Wanzhen was two years older than Tang Yifen, their marriage was likely arranged by their families when they were still young. Dong Wanzhen's depiction of plum and bamboo therefore attest to their dedicated love since childhood.

Besides the use of symbolic and allusive images of plants, insects, birds and animals, the rendition of love in Chinese painting is more conspicuous through narratives of romance with historical or literary references. The famous handscroll *Nymph of the Luo River* by Gu Kaizhi 顧愷之 (346-407), for instance, is based on the prose-poem of the same title by Cao Zhi 曹植 (192-231).[37] Written in the year 223, the poem recounts the romantic fantasy between the prince of Wei 魏 and the goddess, whose love-at-first-sight chance meeting at the Luo River ended in forlornness and sorrow. There are a number of existing copies of Gu Kaizhi's original work, in which the protagonists appear several times to accommodate the story telling. The heartrending theme of the painting as well as the poem, however, has never been considered solely as a love story but has traditionally been colored with Confucian overtones that imply the enigmatic relationship between emperor and minister.[38]

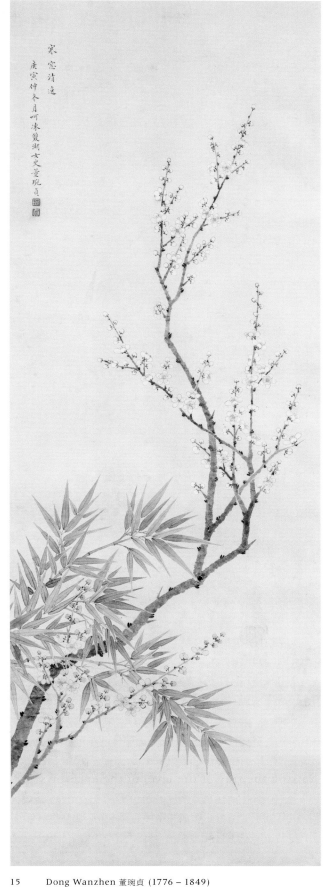

15 Dong Wanzhen 董琬貞 (1776 – 1849)

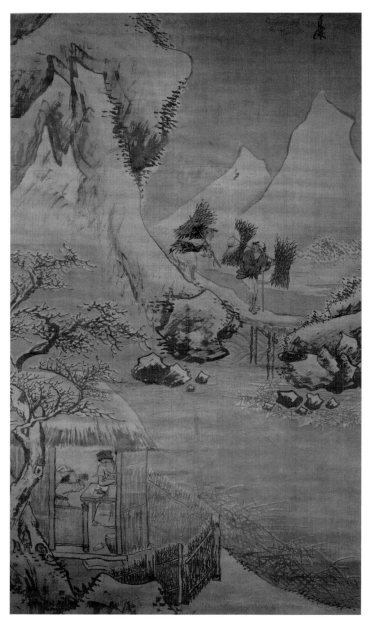

17 *Detail*

16 Wu Shi'en 吳世恩 (active ca. 1500)

Many other love stories in Chinese paintings are also highly charged with Confucian ethical values. One of these popular narratives is about an Eastern Han recluse scholar named Liang Hong 梁鴻 (active ca. late 1st C.) and his spouse Meng Guang 孟光.[39] The hanging scroll by Wu Shi'en 吳世恩 (active ca. 1500) of the Ming dynasty in the Papp collection presents the theme in an expressive brush style typical of the Zhe school of painting [16]. Situated in a winter landscape setting, a thatched hut at the lower left houses the two main characters, among whom Meng Guang is serving food to her husband by "raising the tray at the level of the eyebrows" (舉案齊眉). The wife's act, which demonstrates her expression of love through reverence, was celebrated as a paradigm of ideal woman-hood in the traditional Confucian society. An old couple of hard-working firewood gatherers on a crude bridge in the background further accentuate the theme of marital bliss.

Other frequently rendered historical figures that are related to the love theme include the Emperor Xuanzong 玄宗 (r. 713-756) of the Tang dynasty and his consort Yang Yuhuan (Yang Guifei) 楊玉環 (719-756). Known as one of the most attractive beauties in Chinese history, Yang Yuhuan infatuated Xuanzong to the extent that it caused the downfall of the empire. The consort was blamed for the rebellion led by An Lushan 安祿山 (703-757) and was killed when she and the emperor fled the capital Changan. But the famous couple's tragic story has been treated with great admiration and sympathy in Chinese art and literature, making it an immortal tale of heartbreaking love. A fan painting by the Qing artist Gu Luo 顧洛 (1763 – after 1837) in the Papp collection shows Yang Yuhuan being portrayed by a court painter under a canopied garden terrace surrounded with white blossoming *wutong* 梧桐 (*Firmiana simplex*) trees [17]. Both the portrait making and the *wutong* trees portend the sad ending of the love story. According to historical and literary accounts, the heartbroken Xuanzong "faced the shadows of the neatly planted Wutong trees all alone, missing the devastatingly beautiful face [of his beloved consort]" (空對井梧陰，不見傾城貌。), and he "ordered her image be painted at the auxiliary hall, looking at it day and night." (乃令圖其形於別殿，朝夕視之。)[40] The fact that the emperor recorded his words of bereavement on a portrait of Yang Yuhuan also adds a tinge of sadness to the ostensibly charming scene in Gu Luo's painting.[41]

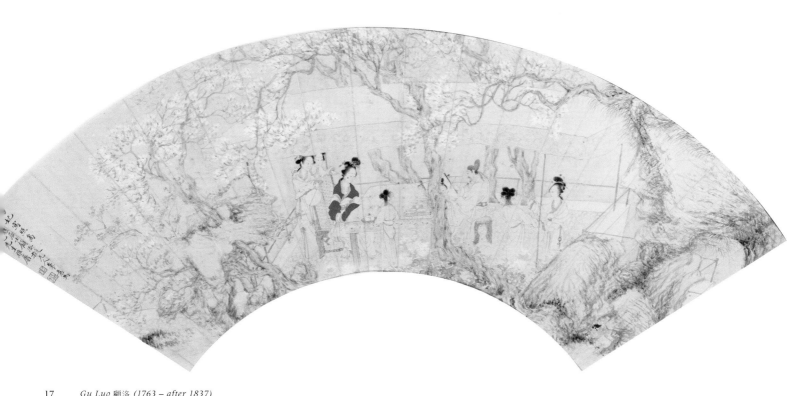

17 *Gu Luo* 顧洛 *(1763 – after 1837)*

A more light-hearted and cheerful romance can be seen in the semi-historical tale about the so-called "Three Heroes in the Wind and Dust" (風塵三俠) from the Tang dynasty. It became a popular theme in Chinese art, especially in 19th century Shanghai. The story narrates about Hongfu Nu, a beautiful courtesan of the Sui minister Yang Su 楊素 (died 606) who eloped with the future Tang general Li Jing; together they built a special friendship with the legendary warrior Qiuran Ke 虬髯客 (Dragon-Beard Man). An album leaf painting done in light ink by the Qing artist Gai Qi 改琦 (1773-1829) [18] depicts the moment Qiuran Ke has intruded into the travel lodge, falling spellbound by Hongfu Nu's beauty while Li Jing keeps a close eye on his lover from without.[42] The artist adopts a jocular tone on the incident with a mock representation of the horse tail as a mirror image of the pretty woman's long strip of hair.

There are other historical or legendary female figures painted by Gai Qi in the same album that deliver the message of love. The album was commissioned by the renowned 18th century scholar Wang Qisun 王芑孫 (1755-1817), a friend and patron of Gai Qi. In the album, Wang Qisun's second wife Cao Zhenxiu 曹貞秀 (1762- after 1822) composed and inscribed sixteen poems about the famous women in the past, upon which Gai Qi's paintings are primarily based.[43] One of the album leaves presents the virtuous Meng Guang performing her household chores [19]. She holds an urn in her hand to prepare the meal, for which she famously served the tray of foods at the level of her eyebrows to her husband Liang Hong. The poem by Cao Zhenxiu further conveys Meng Guang's dedicated care for her loved one:

井臼勞勞一飯艱，	To do house chores was no easy matter, toiling as she must.
未能偕隱買青山。	She could not buy her spouse the blue hills for reclusion.
何時結屋皋橋住？	When could she build a thatched cottage in Gaoqiao?
送老蘆簾帋閣閒。	To send her aging spouse to live leisurely amidst reed curtains and papered doorways.[44]

Other virtuous women famed for their devoted and faithful love also appear in the collaborative album, such as Qin Luofu 秦羅敷 of the Eastern Han period. Qin Luofu's story is recorded in one of the best-known Yuefu poems entitled "Roadside Mulberry," which tells that the young married lady was approached by a ranking official when harvesting mulberry leaves. But she fended off the advances to commit her loyalty to her husband.[45] Qin Luofu is shown in Gai Qi's painting as a graceful and delicate figure collecting mulberry leaves by the roadside using a branch stick [20]. The artist's economic use of brush and monochrome ink creates an austere yet elegant style with an antique flavor that accords perfectly for this portrayal of the famous historical and legendary women of the past.

Several goddesses and female immortals are rendered in the album, including such characters like the Weaving-girl and Wu Cailuan 吳彩鸞 from famous mythological love tales. The Weaving-girl is depicted in one of the album leaves crossing the Milky Way all alone, pining for her lover [21]. She was punished for neglecting her celestial duties after marriage and could only see the Herd-boy once a year on the seventh day of the seventh month when magpies form a bridge for their union.

Hidden Meanings of Love

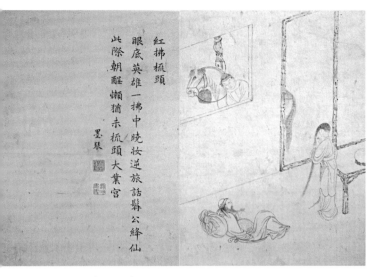

紅拂梳頭

眼底英雄一拂中曉妝逆旅話鬟公絳仙

此際朝醒懶猶未梳頭大業宮

墨琴

18　　Leaf BB and B

Gai Qi 改琦 (1773-1829) Album

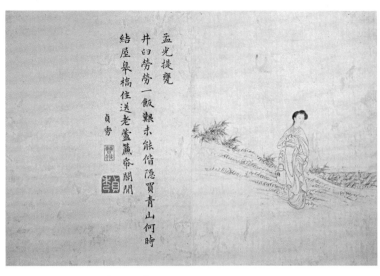

盂光提覽

井臼勞勞一飯艱未能偕隱買青山何時

結屋皋橋住送老蘆簾帝闕間

貞秀

19　　Leaf GG and G

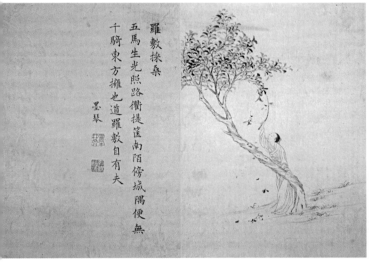

羅敷採桑

五馬生光照路衢提筐南陌傍城隅便無

千騎東方擁也道羅敷自有夫

墨琴

20　　Leaf JJ and J

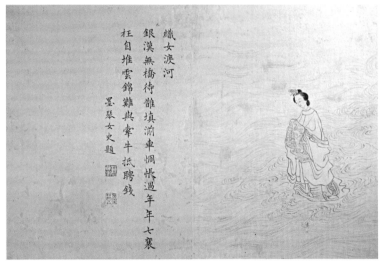

織女渡河

銀漢無橋待鵲填湔車惆悵過年年七襄

枉自堆雲錦難與牽牛抵聘錢

墨琴女史題

21　　Leaf HH and H

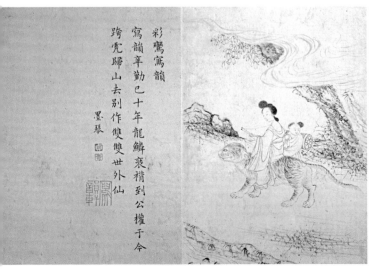

彩鸞寫韻

寫韻辛勤巳十年龍鱗蠶繭稍到公權于今

跨鳧歸山去別作雙雙世外仙

墨琴

22　　Leaf CC and C

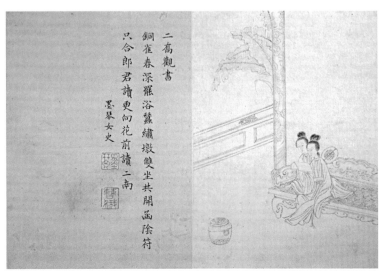

二喬觀書

銅雀春深羅浴蠶繡墩雙坐共開函陰符

只合郎君讀更向花前讀二南

墨琴女史

23　　Leaf KK　　　　24　　Leaf K

Another Daoist immortal Wu Cailuan was also punished to live a harsh life on earth for revealing the secret of destiny. To help her impoverished spouse Wen Xiao 文蕭, Wu Cailuan had to assiduously make hand-copies of the *Tang Yun* 唐韻 (Dictionary of Rhymes) in fine calligraphy for sale to support the family.[46] The painting by Gai Qi shows the immortal riding on a tiger with her son, entering into the celestial realm after a decade of hard work [22].

The most intriguing among the album leaves is a set of painting and calligraphy of poems entitled "Er Qiao Guanshu" 二喬觀書 (The Qiao Sisters Reading a Book Together), which refers to the historical figures Da Qiao 大喬 and Xiao Qiao 小喬 of the Three Kingdoms Period. Noted for their beauty and intelligence, the sisters were married to the emperor of the kingdom of Wu 吳, Sun Ce 孫策 (175-200), and his major military commander Zhou Yu 周瑜 (175-210). According to her biographical account, Cao Zhenxiu, who authored and inscribed the poem, was the second wife of Wang Qisun.[47] The Qiao Sisters therefore are indicative of Cao Zhenxiu's marital status because plural wives in a traditional Chinese marriage were considered as "sisters." This personal relevance of the subject matter is essential for deciphering the hidden meaning of the poem and painting.

In the album leaf painting, Gai Qi presents the Qiao sisters sitting outdoors on an embroidered couch against a wall; one of them is lifting up a book while the other is holding a fan [24]. Behind the wall at the upper left are terrace railings and some banana leaves. And interestingly enough, a solitary *xiudun* 綉墩 (barrel-shaped stool with embroidery pad) is placed at the lower left corner. In this rather simple composition, every setting and object actually has implied reference to love and sex. The stool, either made of wood, porcelain or stone, has a barrel shape that resembles the male member. Its phallic symbolism is even more pronounced with an embroidery pad atop of it. In addition to the similarity in shape, the Chinese word for stool is *dun* 墩. It can be taken as a word play on the term *dunlun* 敦倫, which specifies the marital intercourse between husband and wife.[48] In Gai Qi's painting, the embroidered stool seems to beguile the Qiao sisters' attention from the book they are supposed to be reading. The setting of the scene is reduced to a minimal extent so that the unusual treatment of the seemingly superfluous stool bespeaks its special sexual connotation.

Like the stool, the book is a token of sex frequently seen in Chinese erotic art. The Qiao sisters' reading of a book is also tinged with a hidden meaning of sex. An album leaf painting from the Qianlong period, for instance, displays a courting couple reading a book together inside a chamber.[49] The man is caressing the woman's private part while pointing his finger to the book she is holding. This gesture suggests the erotic imagination of the opened book, whose interior hinge resembles the shape of the female organ. Another painting from an 18th-century erotic handscroll also depicts a scene of sexual flirtation, in which a man is seducing a woman while an opened book is put on the table and an embroidered stool is placed near them.[50] The fan held in one of the Qiao sisters' hand in Gai Qi's painting again has a strong sexual overtone. It is a kind of round-shaped fan, with a single rib in the middle and a slender handle, called *tuanshan* 團扇 (circular fan). The fan rib, which divides the silk veil into semi-circular half and its protruded handle are visually suggestive of the sexual parts of man and woman. Its symbolic meaning is indicated in a poem by the virtuous Han consort Ban Jieyu 班婕妤 (ca. 48- ca. 6 BCE): "(The silk is) trimmed and made into a fan of conjugal pleasure, which is circular in shape like the bright moon." (裁為合歡扇，團團似明月。)[51]

In the background of Gai Qi's painting there is a cluster of banana leaves stretching out from behind the wall. The depiction of the plant is conspicuously related to sex because the Chinese word for banana, *jiao* 蕉, can be used as a pun for the character *jiao* 交, which may mean coitus.[52] Banana therefore has become a symbol of sex in China. In an erotic album leaf painting attributed to the Qing artist Leng Mei 冷枚 (circa. 1669-1742), a young couple is shown in pursuit of sexual hedonism in a garden setting of poetic detachment.[53] Under a canopy of banana leaves, they timorously undress themselves to enjoy sexual intimacy. The appearance of a circular fan and two half-hidden stools signify their desire for coital pleasure.

There is also a section of railings on the left of the painting, indicating an outdoor scene on a terrace. The terrace makes a literary allusion to the *yangtai* 陽台 (sunlit terrace) mentioned in the *Gaotang Fu* 高唐賦 (Poetical Essay on Gaotang) by Song Yu 宋玉 (ca. 298-ca. 222 BCE) of the Warring States Period. In this erotic writing, Song Yu recounts that the King of Chu 楚 visited Gaotang and had a fantasy romance with the Goddess of Wushan 巫山, who described herself as the morning clouds and evening rain, and would appear on the sunlit terrace.[54] Because of this essay, the terms Gaotang, Wushan, *yangtai* and *yunyu* 雲雨 (clouds and rain) all refer to the tryst and sexual activities between lovers in Chinese culture. Gai Qi's arrangement of the Qiao sisters sitting on an embroidered couch on the terrace thus assigns the symbolic meaning of sex to his painting. The embroidered couch, on which coital activities are engaged, also came to stand for sex in China. A famous Ming dynasty erotic novel, for instance, is entitled *Xiuta yeshi* 繡榻野史 (Unofficial History of the Embroidered Couch). In a Qing dynasty album leaf painting, it demonstrates the fantasy of an embroidered couch on the terrace as an ideal setting for sensual delights, where a young couple is about to pursue their sexual desires.[55] The books and the stool on the couch suggest the encounter of the organs.

The terrace, book and stool appear in Cao Zhenxiu's poem [23], which is literally translated:

銅雀春深罷浴蠶，	The spring deepened at Tongque (Terrace) and the work of selecting silk worm eggs had finished.
繡墩雙坐共開函。	The sisters sat on an embroidered barrel-shaped stool and opened their book together.
陰符只合郎君讀，	As the *Yinfu* was a book more fitting for their husbands,
更向花前讀二南。	Against blossoming flowers they were reading the *Ernan*.[56]

Tongque 銅雀 was the grand terrace built by Cao Cao 曹操 (155-220), the emperor of Wei. According to the *Sanguo yanyi* 三國演義 (Romance of the Three Kingdoms) by Luo Guanzhong 羅貫中 (1330-1400), Cao Cao was so enthralled by the beauty of the Qiao Sisters that he built the Tongque terrace, which he intended to use to hold them captive after defeating their husbands on the battlefield.[57] By using the historical reference to Tongque, Cao Zhenxiu not only highlights the beauty of the sisters that infatuated Cao Cao but also suggests the underlying sexual tone of the terrace.

In the starting line of the poem, the word *chun* 春 (spring), which specifies the season of growth and renewal, has traditionally been associated with love and sex in Chinese culture.[58] One of the poems in the *Shijing* reads: "There is a young lady longing for spring/love, and a fair gentleman seduces her." (有女懷春，吉士誘之。)[59] For instance, a

flowery term for sexual congress is *chunfeng yi du* 春風一度, which literally means "one blow of spring wind" and erotic paintings are called *chunhua* 春畫 (spring painting) or *chungong* 春宮 (spring palace).[60] Cao Zhenxiu's use of the phrase *Tongque chunshen* 銅雀春深 therefore reveals a fantasy of sexual pleasure with reference to the place and time of amorous exaltation.[61] The following three characters *ba yu can* 罷浴蠶 in the starting line seem to be read as *ba yucan* at first glance, entailing "the finish of the selection of silkworm eggs."[62] But they can also be interpreted as *bayu can*, in which *bayu* means "after bath" and *can* stands for the two beautiful sisters because it can be taken as a word play on the term with similar pronunciation *chanjuan* 嬋娟 for "pretty woman."[63]

In the second line of the poem, Cao Zhenxiu employs the sexual symbolism of the stool and book in a cleverly devious way. The erotic innuendo of the poem is divulged when the words for stool and book are substituted with their implied meanings, reading: "The sisters sat on a male member and opened their female organs together." It also suggests a coital intercourse between a man and two women. In fact many traditional Chinese sex manuals, such as the Daoist text *Yufang mijue* 玉房秘訣 (Secret Instructions Concerning the Jade Chamber) of the pre-Sui period, promote the idea of copulation with multiple females.[64] This kind of sex practice, which was considered to have therapeutic and health-giving benefits, provided one of the fundamental rationales for polygamy in traditional China.[65]

The other two lines of Cao Zhenxiu's poem are also replete with sexual references. The term *Yinfu* 陰符, which may refer to an ancient Daoist treatise entitled *Huangdi yinfu jing* 黃帝陰符經 (Yellow Emperor's Hidden Talisman Classic), can otherwise be interpreted separately as *yin* and *fu* with different meanings.[66] *Yin* is a common word connoting human sexual organs, like *yinjing* 陰莖 or *yin'gan* 陰幹 for the male part and *yinhu* 陰戶 or *yinmen* 陰門 for the female part. The word *fu* specifies a tally issued by generals as credentials in ancient China. According to Robert Hans van Gulik, the *fu* was broken or torn into two halves so that its authenticity could be proved by fitting them together, thus implying the meeting of the two sexual organs.[67] In the finishing line of the poem, the word *hua* 花 for flower is a stock symbol of pretty women. The term *er Nan* 二南 refers to Zhou Nan 周南 and Zhao Nan 召南, the first two chapters in the *Shijing*. These two chapters of poetry are particularly appreciated for their educational value to women for better serving and satisfying their mates in the bedchamber.[68]

Behind the façade of the historical drama about the Qiao sisters, the "Er Qiao Guanshu" painting and poem are profusely charged with veiled allusions and hidden symbols of love and sex. The set of painting and poem, together with the others in the album, therefore, were primarily executed and used for private amusement and entertainment by Cao Zhenxiu and her husband Wang Qisun. This is probably the reason the painting commission was assigned to their close friend Gai Qi, who marvelously visualized the intimate message of love and sex in a simple style of extraordinary sophistication and elegance.[69] According to his biography, Gai Qi's life was rife with flings and short romances. He paid continual visits to the brothels, having many amorous encounters with courtesans.[70] Like Tang Yin 唐寅 (1470-1524) and Qiu Ying 仇英 (1500-1560), Gai Qi was well versed in erotic painting, especially in the so-called *anchun* 暗春 (hidden erotica). A painting entitled *Young Man Listening to Rain* by the artist, for instance, is famous for his use of hidden symbols of sex. [71]

Hidden Meanings of Love

The new interpretation of the "Er Qiao guanshu" album leaves also provides a fresh insight into the reading of certain Chinese paintings that have not previously been considered as related to the themes of love and sex. A late-Ming painting traditionally attributed to Sheng Shiyan 盛師顏 (fl. 13th C.) of the Song period in the Freer Gallery of Art shows a female figure reading a book.[72] It seems to be a typical rendition of the *meinu* 美女 (beauty) genre, depicting a young lady with grace and demureness entertaining herself with a book of poems in her boudoir of tranquil allure. But its underlying import can be grasped through the visual clues provided by the seemingly trivial and insignificant objects on and around the figure. The jade ornament dangled from her waist is called *hebi lianhuan* 合璧連環 (interlocking jade rings), which was used as a keepsake of love in the past. Other interpretative hints include the couch with embroidered cover, suggesting a desire for sensual pleasure. The couch frame fashioned of twisted roots is indicative of the intimate bonds of affection as well as the entwined lovers. Even more revealing is the use of the sexual symbols of book and stool in a commonplace interior scene. Surrounded by all these mind-stirring objects, the young lady could hardly be comforted by the hand warmer on the couch with a heart laden with emptiness and loneliness.

The iconography of a woman reading a book, which had been invested with the symbolisms of love and sex by the late-Ming period, is presented in an album leaf painting entitled *Piao Xiang* 縹香 (Fragrance of the Book) by Chen Hongshou 陳洪綬 (1598-1652) in the National Palace Museum in Taipei.[73] As pointed out by Wang Yaoting, the painting is imbued with a romantic atmosphere and the figure is probably modeled after the artist's concubine Hu Jingman 胡淨鬘 (fl. circa. 1543).[74] There is, nevertheless, a secret layer of meaning hidden beneath the mere depiction of a beautiful woman with amorous admiration. The figure stares away from the book in distraction, whose reading is nothing but a disguised act of sex fantasy. Concealed by the long sleeves, her right hand is placed over her private part while the other hand is lifting up an opened book, again a symbol of the female sexual organ. Chen Hongshou's daring yet playful treatment of the theme is evinced in his depiction of a large and dark phallic-shaped stone with an embroidered cover, on which the lady is timidly sitting to create a satirical tone. The artist's ingenuity is even more pronounced in his naming of the title *Piao Xiang*. The word *piao* 縹, which literally means light blue fabric, may refer to the cover of the book and the dress of the figure, thus making the title a double entendre for the fragrance of the body part.[75]

A portrait of the Song poetess Li Qingzhao 李清照 (1084–ca.1151) by the Qing artist Cui Wei 崔錯 (fl. early 19th C.) in the Beijing Palace Museum can also be reinterpreted with the new perspective on the iconography of a woman reading a book.[76] In the painting the poetess, who became a widow in her early thirties, is all alone in her study with an opened book placed in front of her on a long narrow table. She is distracted from reading and is lost in brooding over the objects on the foreground. The incense burner in the shape of a mandarin duck is a common love token while the stand with interlocking branches of roots is insinuative of the inextricable affection between lovers. As an analogy for the consuming fire of love, the incense burner proper harbors an amorous content.[77] The barrel-shaped stool purposely placed at the lower right corner and the unattended book on the table are treated as fetishes for sexual arousal and fantasy. Together these hidden symbols suggest Li Qingzhao's tender recollections of her deceased husband as well as a desperate need and desire for love and sex, which became the main focus and obsession in her poems.[78]

Another prime example of the iconography of a woman reading a book is a life-size painting from a set of twelve panels formerly installed at the Qing emperor's summer palace Yuanming Yuan 圓明園 (Gardens of Perfect Brightness)[79]. A court lady is shown all by herself inside her boudoir, getting carried away from reading by titillating thoughts. The figure's amatory mood is indicated in a poetic calligraphy by Mi Fu 米芾 (1051-1107) used as wall decoration behind her:

櫻桃口小柳腰肢，	The tiny mouth is like a cherry and the slim waist a willow twig.
斜倚春風半懶時。	It's time to relax and sway in the spring wind.
一種心情費消遣，	Consuming the time with a special feeling and mood,
緗編欲展又凝思。	(The lady) intends to open the book but is lost in contemplation.

In the painting the flowers on the table and the bamboo outside the window stand for a pretty woman and a gentleman. They are now separated apart by the walls that imprison the body and heart of the lady. The high wooden stand with its legs formed by entwined roots again implies the intimate bond between lovers. On the stand there is a black lacquered box in the shape of a water chestnut. This vegetable, which is called *biqi* 荸薺 in Chinese, can work as a pun for *qi* 齊, meaning "conjugal union."But the stand and the water chestnut box are out of reach in a separate compartment over the threshold.

Languishing away for an absence of love, the court lady sits entranced on an embroidered stool holding an opened book in her hand. She feels frustrated for being neglected and love deprived, and her longing for an absent lover is explicitly illustrated in the three poems written on the opened pages of the book. The poetic lines read: "My husband is in high spirits in his prime youth, in which house he will be drunk and stay tonight?" (良人得意正年少，今夜醉眠何處樓？); "My heart of loyalty and devotion, I worry, may not get your attention." (丹心寸意，愁君未知。) and "Gather sweet flowers while you may, and not the twig of flowers until they fade." (花開堪折直須折，莫待無花空折枝。).[80] The solitary lady can only seek solace through imagination and fantasy. She positions her left hand with a suggestive finger gesture on her private part while the erotic nature of the stool and book provokes the sexually arousing feelings that make her face flushed in red.

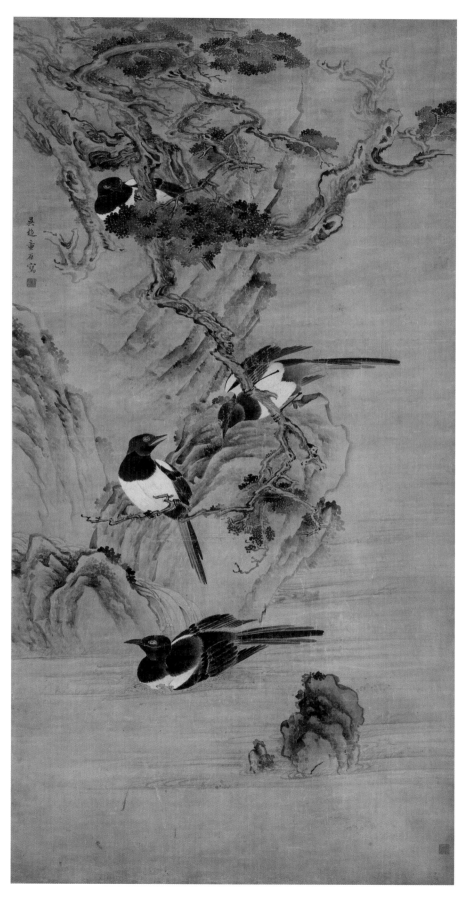

3 Tong Yuan 童原 (active 17th C.)

Notes to Hidden Meanings of Love

1. Kong Yingda explicates in his *Maoshi zhushu*: "The poems that use plants, trees, birds and animals to express the ideas are words of *xing* (metaphor)." (詩文諸舉草木鳥獸以見意者，皆興辭也。) *Maoshi zhushu*, *juan* 1, 11a. Also, the Eastern Han scholar Wang Yi (d. ca.158) points out in his *Chuci Zhangju* 楚辭章句 (Commentary to the *Songs of Chu*): "The writing of *Li sao* adapted *Shijing*'s use of *xing* (metaphor) to draw on types to make comparisons. Therefore, fine birds and fragrant plants are used to correspond to loyalty and steadfastness; vicious animals and foul objects are used as comparisons to slanderous and villainous people..." (《離騷》之文，依《詩》取興，引類譬諭，故善鳥香草、以配忠貞；惡禽臭物，以比讒佞...) Wang Yi annot., *Chuci Zhangju* (*SKQS*), *juan* 1, 2a.

2. *Maoshi zhushu*, *juan* 21, 42b.

3. Mao Xiang, a renowned scholar from Rugao 如皋 of Jiangsu province, had two concubines, Cai Han and Jin Yue 金玥 (fl. 1662-1675), who were both accomplished in painting. Cai Han, *zi Nuluo* 女蘿, *hao Yuanyu* 圓玉, was from Wuxian 吳縣 of Jiangsu province.

4. In Guo Maoqian 郭茂倩 (1041-1099) comp., *Yuefu shiji* 樂府詩集 (A Compilation of Yuefu Poems) (*SKQS*), *juan* 74, 1b.

5. Du Guangting's essay was first recorded in Li Fang 李昉 (925-996) et al. comps., *Taiping guangji* 太平廣記 (Extensive Records of the Taiping Reign) (*SKQS*), *juan* 193, 2a. One of the two artist's seals placed at the lower left reads: "yi zi Nuluo 一字女蘿" (A literary name Nuluo).

6. One of the poems by Cao Zhi 曹植 (192-231) reads: "Below, there are animals crossing their necks; and up above, a pair of perching birds can be seen." (下有交頸獸，仰見雙棲禽。) Cao Zhi, *Cao Zijian ji* 曹子建集 (Collected Works of Cao Zijian) (*SKQS*), *juan* 6, 9b.

7. For the image and brief description of the painting, see Guoli Gugong Bowuyuan 國立故宮博物院 ed., *Gugong shuhua tulu* 故宮書畫圖錄 (National Palace Museum Illustrated Catalogue), vol. 1 (Taipei: National Palace Museum, 1989), 301-302. The emperor Huizong's poem reads: "Mountain birds are proud and unfettered; plum blossoms' pollen is soft and light. The painting will be our covenant; we will live a thousand autumns and become white-headed together." (山禽矜逸態，梅粉弄輕柔。已有丹青約，千秋指白頭。)

8. The Northern Song scholar Peng Cheng 彭乘 (985-1049) notes: "The sound of the magpie often invites good luck, seldom brings bad luck. Therefore, it is commonly known as the happy magpie." (鵲聲吉多而凶少，故俗呼喜鵲。) Peng Cheng, *Moke huixi* 墨客揮犀 (Pure Conversation of Scholars), *juan* 2, 4b.

9. The story tells: "The Weaving-girl at the east of the Milky Way, the daughter of the Emperor of the Heaven, worked very hard by weaving the clouds and mists year after year. Seeing that she was too busy to care for her appearance and to stay alone, the Emperor took pity for her loneliness and agreed that she marry to the Herd-boy on the west of the Milky Way. After the marriage, the Weaving-girl became idle with her job which angered the emperor. As a result, she was ordered to return to the east and could only spend one day of each year with her Herd-boy." (天河之東有織女，天帝之子也。年年機杼勞役，織成雲錦天衣，容貌不暇整。帝憐其獨處，許嫁河西牽牛郎，嫁後遂廢織紝。天帝怒，責令歸河東，但使一年一度相會。) Quoted in Chen Yaowen 陳耀文 (1573-1619), *Tianzhong ji* 天中記 (Records from Tianzhong), *juan* 2, 36b.

10. For the images of the paper-cuts using the ligature and two magpies as designs, see Wang Weihai 王維海 and Shao Meiyu 邵美玉, *Zhongguo minjian shuangxi tuan jianzhi* 中國民間雙喜圖案剪紙 (Chinese Folk Paper-cuts with Xuangxi Designs) (Shengyang: Liaoling Meishu Chubanshe, 2000).

11. Wolfram Eberhard, *A Dictionary of Chinese Symbols: Hidden Symbols in Chinese Life and Thought*, trans. G.L. Campbell (London and New York: Routledge, 1988), 89.

12. Translation by Howard Rogers with changes in Ju-hsi Chou, *Heritage of the Brush, The Roy and Marilyn Papp Collection of Chinese Painting*, (Phoenix: Phoenix Art Mueum, 1998), 72.

13. The poem "Viewing Crabapple at the Zhang Garden" by Lu You 陸遊 (1125-1210) writes: "[The flower] looks gorgeous and colorful, but not common and cheap; it is the 'superior emperor' and truly represents wealth and nobility." (雖豔無俗姿，太皇真富貴。) Lu You, *Jiannan shigao* 劍南詩藁 (Collected Poems of Jiannan) (*SKQS*), *juan* 9, 30b. Also, Zhou Dunyi's 周敦頤 (1017-1073) essay "On the Love of Lotus" says: "Peony is the flower of wealth and nobility." (牡丹，花之富貴者也。) Zhou Dunyi, *Zhou Yuangong ji* 周元公集 (Collected Works of Zhou Yuangong) (*SKQS*), *juan* 2, 2a.

14. The crabapple refers to *mantang* because the Chinese call the plant *haitang* 海棠, a term whose second character is homophonous to *tang* 堂 (hall), which stands for the family. And the peony is known as *fugui hua* 富貴花, meaning "flower of wealth and nobility." See Terese Tse Bartholomew, *Hidden Meanings in Chinese Art* (San Francisco: Asian Art Museum, 2006), 137.

15. The poem by Cao Rui 曹叡 (205-239), the emperor of the Wei Kingdom, is collected in *Gu yue yuan* 古樂苑 (Collection of Ancient Yuefu Poems) compiled by Mei Dingzuo 梅鼎祚 (1549-1615). Mei Dingzuo comp., *Gu yue yuan* (*SKQS*), *juan* 16, 12b.

16 Known for its graceful features and the medical potency of its young antlers, the deer has been regarded as an auspicious animal symbolizing longevity and prosperity in China. See Eberhard, *A Dictionary of Chinese Symbols*, 79.

17 For instance, an anonymous poem entitled "Song of Midnight" from the Southern Dynasties writes: "[My] joy and sadness make you sick, and your laughter makes me happy. Do not you see, the interlocked trees have separate roots but grow together." (歡愁儂亦慘，郎咲我亦喜。不見連理樹，異根同條起。) Mei, *Gu yue yuan*, juan 23, 5a.

18 Bai Juyi, "Song of Everlasting Regret," *Bai Xiangshan shiji* 白香山詩集 (Collected Poems of Bai Xiangshan) (*SKQS*), juan 12, 16b.

19 For the meaning of the rebus *fenghou* and the symbolism of pomegranate, see Terese Tse Bartholomew, *Hidden Meanings in Chinese Art*, 76,118.

20 Translation from Ju-hsi Chou with changes, *Scent of Ink*: *The Roy and Marilyn Papp Collection of Chinese Painting* (Phoenix: Phoenix Art Museum, 1994), 96.

21 Wen Yiduo 聞一多 (1899-1946) illuminates the metaphorical meaning in his famous studies of ancient poems: "There is a use of metaphors of fish as men and lotus as women; thus the saying of fish having fun with lotus actually refers to the relations and making love of men and women." (用魚喻男，蓮喻女，說魚與蓮戲，實等於說男與女戲。) Wen Yiduo, "On Fish," *Wen Yiduo quanji* 聞一多全集 (Complete Collection of Works of Wen Yiduo), vol.1 (Taipei: Liren shuju, 2000), 121.

22 For instance Zhang Kejiu 張可久 (ca.1285-after 1348) of the Yuan dynasty uses golden lotus and jade rhizome as metaphors for women's bound foot and soft arm in his lyric verse: "The golden lotus moves a little step, and the fragrant cheek rests on the jade rhizome." (金蓮小步移，玉藕香腮枕。) Yang Chaoying 楊朝英 (ca.1285-1355) comp., *Chaoye xinsheng taiping yuefu* 朝野新聲太平樂府 (New Sounds for a Magnificent Age. Yuefu Poems in the Era of Peace and Joy) (*Shibu congkan* 四部叢刊), juan 4, 11a.

23 The nude, especially the female nude, can only be found in the erotic pillow books or Daoist sexual manuals. See Robert H. van Gulik, *Sexual Life in Ancient China* (Leiden: Brill, 1974), 200-202, 318-333.

24 The inscription states: "Take Fang [Gang] Xiongfei's verse, and then use Xu Qingteng's (Xu Wei's) brush." See Ju-hsi Chou, *Scent of Ink*, 98.

25 These "Four Poems Dedicated to a Pretty Lady" are collected in Fan Gang, *Xuanying ji* 玄英集 (Collected Works of Xuanying) (*SKQS*), juan 6, 1b.

26 Wolfram Eberhard discusses the symbolism of cicada in his book: "Representation of a cicada on a hat symbolizes an honest man of principle." See also his discussion of the willow. *A Dictionary of Chinese Symbols*, 66 and 314.

27 Translation from Ju-hsi Chou *Scent of Ink*, 97.

28 *Maoshi zhushu*, juan 1, 53b.

29 For instance, a poem by Xiao Gang 蕭綱 (503-551), the emperor of Liang 梁, reads: "The butterfly flies across the stairs, showing infatuation with the flowers. The handsome flying swallows meet face to face." (翻階蛺蝶戀花情，容華飛燕相逢迎。) *Yuefu shiji*, juan 68, 4a.

30 *Hao* or *biehao* 別號 is a name usually created by the individual themselves. There are various methods of developing a *hao* and the most common one is to express one's main interest and goal in life. See Hu Axiang 胡阿祥 and Lu Haiming 盧海鳴, *Zhongguo gujin minghao xunyuan shiyi* 中國古今名號尋源考釋 (Study of Names and Sobriquets of the Past and Present) (Shenyang: Liaohai chubanshe, 2001).

31 Zheng Zhenduo 鄭振鐸 (1898-1958) explicates the metaphor in his "Literature about Butterflies": "The pieridae butterfly flies lively between flowers, it stays on this flower for a while and then stays on that flower for a while, just like a man who engages in many love affairs." (粉蝶栩栩的在花間飛來飛去，一時停在這朵花上，隔一瞬，又停在那一朵花上，正如情愛不專一的男子一樣。) Zheng Zhenduo, "Literature about Butterflies," *Zheng Zhenduo sanwen xuanji* 鄭振鐸散文選集 (A Collection of Prose by Zheng Zhenduo) (Tianjin: Baihua wenyi, 1989), 37.

32 As Ju-hsi Chou points out in his catalog entry, the real depiction of conjugal intimacy of Qian Yuling and her husband is rare in Chinese painting. See *Journeys on Paper and Silk*, 112.

33 In the *Nan shi* 南史 (History of the Southern Dynasties) by Li Yanshou 李延壽 (fl. early 7th C.), it records a poem composed by a woman of chastity to commemorate her deceased husband: "A cypress grows in front of the grave, having its roots joined together and its branches connected. My heart can move the tree, hence the dilapidated city should not be surprised." (墓前一株栢，根連復並枝。妾心能感木，頹城何足奇。) Li Yanshou, *Nan shi*, (*SKQS*), juan 74, 10b.

34 *Yutai huashi* is comprised of five *juan*, in which the recorded 223 female artists are grouped into four categories, namely palace ladies, renowned women (from prominent families), wives and concubines (of famous men) and courtesans. For a discussion on the book, see Xu Yuhong 徐玉紅, *Yutai huashi yanjiu* 玉台畫史研究 (Research on the *History of Painting from the Jade Terrace*) (Hangzhou: Zhongguo meishu xueyuan chubanshe, 2012).

35 The poem "A Song of Changgang" by Li Bai reads: "On bamboo horse my lover came upon the scene, around the well we played with plumes still green. We lived, close neighbors on Riverside Lane; carefree and innocent, we children twain." (郎騎竹馬來，遶牀弄青梅。同居長幹裏 ，兩小無嫌猜。) Li Bai, *Li Taibai wenji* 李太白文集 (Collected Works of Li Taibai) (*SKQS*), juan 3, 9b.

36 Ouyang Yuqian, *Kongque dong nan fei* (Hong Kong: Yimei tushu, 1956), 15.

37 For the image and discussion of the painting, see Shane McCausland, *First Masterpiece of Chinese Painting: The Admonitions Scroll* (London: British Museum Press, 2003).

38 Cao Zhi expresses the emotion of fidelity in his poem: "Although she hides beneath in the Great Yin, she always puts the emperor on her heart." (雖潛處於太陰，長寄心于君王) Cao Zhi, "Ode to Nymph of the Luo River," *Cao Zijian ji* 曹子健集 (Collected Works of Cao Zijian) (*SKQS*), *juan* 3, 4b.

39 Fan Ye 范曄 (394-446), *Hou Han shu* 後漢書 (History of the Later Han Dynasty) (*SKQS*), *juan* 113, 13a.

40 The *wutong* tree can be taken as a pun for the term *wutong* 吾同, which means "we together". Bai Pu 白樸 (1226-1306), *Wutong yu* 梧桐雨 (Rain on the Wutong Trees), in Zang Maoxun 臧懋循 (1550-1620) comp., *Yuan qu xuan yibai zhong,* 元曲選一百種 (A Collection of a Hundred Yuan Dramas) (*Sibu congkan*), 578. Liu Xu 劉昫 (887-946), *Jiu Tang shu* 舊唐書 (Old History of Tang Dynasty) (*SKQS*), *juan* 51, 27a.

41 The short essay entitled "Ode to the Consort's Portrait by Wang Wenyu" is collected in Dong Gao 董誥 (1740-1818) et al. comps., *Quan Tang wen* 全唐文 (A Complete Collection of Tang Prose), vol.1 (Shanghai: Shanghai guji, 1990), 193.

42 The year of Gai Qi's death is based on the biographical research done by He Yanzhe 何延喆. He Yanzhe, *Gai Qi Pingzhuan* 改琦評傳 (A Critical Biography of Gai Qi) (Tianjin: Tianjin Renmin Meishu Chubanshe, 1998), 6-7.

43 The poems are collected in the book entitled *Xieyun Xuan xiaogao* 寫韻軒小藁 (Manuscripts from Xieyun Studio). Cao Zhenxiu, "Sixteen Assorted Poems on Paintings," *Xieyun Xuan xiaogao* (二卷續增卷, 1815 reprint: Shanghai Guji Chubanshe, 2010), *Juan* 1, 14a-16b.

44 Translation from Ju-hsi Chou with changes, *Journeys on Paper and Silk*, 141.

45 The poem is collected in Guo, *Yuefu shiji, juan* 28, 6a-7b. Qin Luofu's story is also recorded in the *Leinu zhuan* 列女傳 (Biographies of Exemplary Women) by Liu Xiang 劉向 (79-8 BCE). But the story has a sad ending with the virtuous woman committing suicide after knowing that the womanizer she came across was actually her husband who had left home for many years. Liu Xiang, *Leinu zhuan* (*SKQS*), *juan* 5, 11a-12b

46 The story about Wen Xiao and Wu Cailuan is recorded in Du Guangting's *Xianzhuan shiyi* 仙傳拾遺 (Lost Records of Biographies of Immortals). In Yan Yiping 嚴一萍 (1912-1987) ed., *Daojiao yanjiu ziliao* 道教研究資料 (Research Materials on Daoism), vol.1 (Taipei: Yiwen yinshuguan, 1991), 22.

47 For the biography of Cao Zhenxiu, see Chen Jinling, "Cao Zhenxiu," trans. S.M. Kwan, in *Biographical Dictionary of Chinese Women: The Qing Period, 1644-1911,* eds. Lily Xiao Hong Lee and A.D. Stefanowska (New York: M.E. Sharpe, 1998), 13.

48 In his letter "Reply to Yang Lihu," the famous Qing poet Yuan Mei 袁枚 (1716-1798) states: "Li Gangzhu (1659-1733) was proud of his scholarship of honesty and integrity, he wrote on his diary: 'Last night I "promoted feudal ethics" (made love) with my old wife.'" (李剛主自負不欺之學，日記云：「昨夜與老妻『敦倫』一次。」) Yuan Mei, *Xiaocang Shanfang chidu* 小倉山房尺牘 (Letters from Xiaocang Mountain Retreat) (Taipei: Zhengshen Shuju, 1970), 338.

49 For the image of the painting, which is from an album of eight leaves now in the Bertholet collection, see Bertholet, *Gardens of Pleasure*, 160-161

50 The painting is from a handscroll of 16 paintings in the Bertholet collection. *Gardens of Pleasures*, 93.

51 *Yuefu shiji, juan* 42, 3b

52 Many Chinese terms formed with the prefix *jiao,* such as *jiaogou* 交媾, *jiaojie* 交接, *jiaohe* 交合, *jiaohui* 交會 or *jiaohuan* 交歡, all mean coital intercourse.

53 This painting is from an eight-leaf erotic album by Leng Mei, which is listed in the catalog written by Paul Moss. See *The Literati Mode: Chinese Scholar Paintings, Calligraphy and Desk Objects* (London: Sydney L. Moss Ltd., 1986), 84.

54 According to Robert H. van Gulik's translation, the preface reads: "The former King once made an excursion to Gaotang. Feeling tired he there slept during the daytime. He dreamt that he met a woman who said to him: 'I am the Lady of the Wu Mountain, and temporarily reside here in Gaotang. Having heard that you have come here I wish to share pillow and couch with you.' Thereupon the King had sexual intercourse with her. At parting she said: 'I live on the southern slope of the Wu Mountain, on the top of a high hill. At dawn I am the morning clouds, in the evening I am the pouring rain. Every morning and every night I hover about beneath the Yang Terrace." (先王游高唐，怠而畫寢。夢見一婦人，曰：妾巫山之女也，為高唐之客。聞君游高唐，願薦枕席。王因幸之，去而辭曰：妾在巫山之陽，高丘之阻。且為朝雲，暮為行雨；朝朝暮暮，陽台之下。) Robert H. van Gulik, *Erotic Colour Prints of the Ming Period: With an Essay on Chinese Sex Life from the Han to the Ch'ing Dynasty, B.C. 206 – A.D. 1644* (1951, reprint in Taiwan), 230.

55 The novel *Xiuta yeshi* is attributed to the Ming playwright Lu Tiancheng 呂天成 (1580-1618). For the English translation of the novel, see Lenny Hu trans., *The Embroidered Couch* (Vancouver: Arsenal Pulp Press, 2001). The album leaf is also from the Bertholet collection. For an image of the painting, see Lin Liao Yi, The Tao of Seduction: Erotic Secrets from Ancient China (New York: Abrams, 2007), 77.

56 Translation from Ju-hsi Chou with changes, *Journeys on Paper and Silk*, 143.

57 In chapter 44 of the *Sanguo yanyi*, the author writes: "[Cao] Cao once swore an oath: 'I wish I could conquer the whole country to establish a great empire. I also wish I could capture the Qiao Sisters from Jiangdong and keep them at Tongque Terrace to enjoy my later years. Then I will have no regret in my life.'" (操曾發誓曰:「吾一願掃平四海,以成帝業;一願得江東二喬,置之銅雀台,以樂晚年,雖死無恨矣。」) Luo Guanzhong, *Sanguo yanyi* (*Diyi caizi shu* 第一才子書) (reprint, Taipei: Qingshan chubanshe, 1977), *juan* 22, 9a.

58 Wolfram Eberhard, *A Dictionary of Chinese Symbols: Hidden Symbols in Chinese Life and Thought*, trans. G.L. Campbell (London and New York: Routledge & Kegan Paul, 1986), 275.

59 *Maoshi jushu, juan* 2, 45a.

60 In the late Qing novel *Huayue hen* 花月痕 (The Mark of Flower and Moon) by Wei Xiuren 魏秀仁 (1819-1874), the author writes: "Surprisingly, Bitao was able to endure the 'one blow of spring wind' (sexual intercourse); in fact she showed up all her seductive charm." (不料碧桃竟禁得起春風一度,而且曲盡媚嫵之態。) Wei Xiuren, *Huayue hen* (Taipei: Taipei Guji, 2004), 472.

61 The phrase *Tongque chunshen* is clearly indebted to a poetic line by Du Mu 杜牧 (803-852), who was notorious for his romantic escapades. Du Mu's poem reads: "On a part of a spear still unrusted in the sand. I have burnished the symbol of an ancient kingdom. Except for a wind aiding General Zhou Yu, Spring would have sealed both Qiao sisters in Tongque Terrace." (折戟沈沙鐵未銷,自將磨洗認前朝。東風不與周郎便,銅雀春深鎖二喬。) Translation from Witter Bynner with changes. *The Jade Mountain: A Chinese Anthology, Being Three Hundred Poems of the T'ang Dynasty, 618-906* (New York: Knopf, 1929), 175.

62 *Chan* 嬋 may sound very close to *can* 蠶 in some Chinese dialects. The term *yucan* 浴蠶, whose translation by Ju-hsi Chou as "the bathing of silkworms" is problematic, refers to the selection of silkworm eggs in a special solution. It was domestic work specific to women in traditional China, as reflected in the poetic line "Mother and wife are calling each other to do the work of selecting silkworm eggs" (婦姑相喚浴蠶去) by Wang Jian 王建 (ca.766 – after 831). "Mother and wife are calling each other to do the work of selecting silkworm eggs." (婦姑相喚浴蠶去) Wang Jian, "Rain over a Mountain Village," in Peng Dingqiu 彭定求 (1645-1719) et al. comps., *Yuding quan Tang shi* 御定全唐詩 (Imperially Commissioned Compilation of Tang Poems) (*SKQS*), *juan* 301, 17b-18a

63 *Can* may also suggest one of the sexual positions called *can chanmian* 蠶纏綿 (silkworms tenderly entwined) as recorded in the Daoist text *Dongxuanzi* 洞玄子 (Master Dongxuan) of the Tang Dynasty.

There are thirty sexual positions discussed in *Dongxuanzi*, in which *can chanmian* is the forth one. See Douglas Wile, *Art of Bedchamber: The Chinese Sexual Yoga Classics Including Women's Solo Meditation Text* (New York: State University of New York Press, 1992), 109.

64 The *Yufang mijue* states: 'If you change women often, many are the benefits. It is especially beneficial if you have more than ten partners a night...' (數數易女則益多,一夕易十人以上尤佳...) Quoted in Fang Fu Ruan, *Sex in China, Studies in Sexology in Chinese Culture* (New York: Plenum Press, 1991), 58.

65 See John Byron, *Portrait of a Chinese Paradise: Erotica and Sexual Customs of the Late Qing Period* (London: Quartet Books, 1987), 13-14.

66 The content and meaning of the *Huangdi yinfu jing* has long been a source of scholarly debate from military strategy to astrology and Daoist inner alchemy.

67 See Robert H. van Gulik, *Erotic Colour Prints of the Ming Period*, 158-159. The term *yinfu* can be designated as a female sexual organ, as shown in the chapter title "Play with the Shengnu's Vagina in Clouds and Rain" (搏雲搓雨弄神女陰符) in the novel *Niehai hua* 孽海花 (A Flower in the Sea of Sins) by Zeng Pu 曾樸 (1871-1935).

68 The late-Han Confucian scholar Zheng Xuan 鄭玄 (127-200), for instance, notes in his *Maoshi pu* 毛詩譜 (Manual on the *Shijing*): "[Ernan] can be called the music of the bedchamber, through which the empresses and imperial concubines serve their gentlemen..." (或謂之房中之樂者,後妃夫人侍禦於其君子...) *Maoshi zhushu, Maoshi pu*, 8a.

69 The friendship between the couple and Gai Qi is recorded in Wang Qisun's writing. Wang Qisun, *Yuanya tang quanji* 淵雅堂全集 (Complete Writings from Yuanya Hall) (1803; reprint, Shanghai: Shanghai Guji Chubanshe, 1995), 398.

70 Gai Qi's wife passed away when he was around thirty. He remained a widower until his death but became a frequent visitor to brothels. Gai Qi did many paintings and poems for the courtesans and he was mentioned in the same breath with the rakish Tang poet Du Mu 杜牧 (803-852). A discussion of the institution of the courtesan in its cultural and social contexts was done by Robert H. van Gulik. See *Sexual Life in Ancient China*, 178-179.

71 The sexual connotations of this painting are discussed by He Yanzhe in his book. See *Gai Qi Pingzhuan*, 44-47, 52.

72 An image of the painting may be found at http://collections.si.edu/search/results.htm?q=record_ID:fsg_F1919.155. For the image and brief description of the painting, see Zhao Guangchao 趙廣超 and Wu Jingwen 吳靖雯, *Shier meiren* 十二美人 (Twelve Beauties), vol. 2 (Hong Kong: Joint Publishing, 2011), 77-78.

73 For the image and brief description of the painting, see *Gugong shuhua tulu*, vol.23, 238-243. The painting title is translated as "Blue-Silk Fragrance" in an exhibition catalog published by the National Palace Museum in Taipei in 1988. See *Glimpses into the Hidden Quarters: Paintings of Women from the Middle Kingdom* (Taipei: National Palace Museum in Taipei, 1988), 93. A more accurate translation should be "Fragrance of the book." The word *piao* stands for the book because of its frequent use of light blue fabric cover in the past, as demonstrated in the flowery terms *piao shu* 縹書, *piao xiang* 縹緗 and *piao zhi* 縹帙 for books.

74 See Wang, "Images of the Heart," *National Palace Museum Bulletin* 22.5, 6-7

75 As observed by Wang Yaoting, Chen Hongshou's painting "depicts a young woman clothed in pale blue silk seated on a rock covered with a length of patterned brocade. Ibid., 6

76 For the image and brief discussion of the painting, see Laing, "Chinese Palace-Style Poetry and the Depiction of a Palace Beauty," 288-289

77 Ibid., 289.

78 Because of the explicit expression of love and sex in her poems, Li Qingzhao has been criticized as "the most shameless" woman writer. See Hu Pin-ching, *Li Ch'ing-chao* (New York: Twayne Publishers, 1966), 63.

79 For the image and brief description of the painting, see Zhao Guangchao 趙廣超 and Wu Jingwen 吳靖雯, *Shier meiren* 十二美人 (Twelve Beauties) (Hong Kong: Joint Publishing, 2011) vol. 1, 4

80. Zhao Shi 趙氏 (fl. late 8th C.), "Acknowledging Du Gao Stood First at the Imperial Examination," in Gao Bing 高棅 (1350-1423) comp., *Tang shi pin hui* 唐詩品彙 (Categories of Tang Poetry) (*SKQS*), *juan* 55, 16b-17a; Wu Jun 吳均 (468-520), "Song of Qingxi Young Lady," in Feng Weine 馮惟訥 (1512-1572) comp., *Gu shi ji* 古詩紀 (Records of Ancient Poems) (*SKQS*), *juan* 144, 4b-5a; Du qiu niang 杜秋娘, (fl. 8-9th C.) "Gold Threaded Robe," in *Yuding quan Tang shi*, *juan* 28, 20b

11 Qian Feng 錢灃 (1740-1795) Detail — full view on page 63

Hidden Meanings of Death

The representation of death in Chinese art, except in the folk and liturgical areas, has long been suppressed, mainly due to the Confucian teachings that focus primarily on this-worldly issues while discouraging people from worrying about mortality and the afterlife. Its treatment in painting, as compared to other cultures, is ostensibly indirect, suggested only through symbolic and allusive images. Unlike in Western art, depictions of the deceased or other obvious symbols of death like human skeletons are extremely rare in China. One of the very few examples is a small album painting entitled *Puppet Play of a Skeleton* by the Southern Song court artist Li Song 李嵩 (1166-1243) in the Beijing Palace Museum.[1] In the painting a symbolic figure of death, in the guise of a street performer, is playing a skeleton puppet in front of two toddlers. Despite the warning from the elder girl, the boy is crawling towards the puppet, utterly unaware of its meaning of death. The modern viewers may easily apprehend and appreciate the theme of this painting with its recognizable images of death, but the educated Chinese elite of the past probably regarded such representation as superficial and unsophisticated.

Traditional Chinese literati painters tended to employ more indirect artistic means. A subtle treatment of the theme of death is demonstrated in a tall hanging scroll painting entitled *Lin Daiyu Burying Fallen Blossoms* by the versatile Hangzhou artist Gu Luo in the Papp collection [1]. Based on a pivotal scene from the masterpiece Qing novel *Honglou meng* 紅樓夢 (Dream of the Red Chamber) by Cao Xueqin 曹雪芹 (1715-1763), it depicts the moody heroine Lin Daiyu 林黛玉, after bickering with her lover Jia Baoyu 賈寶玉, sitting in melancholy at the corner of a solitary garden. With the rake and broom cast aside by her feet, she feebly unwraps a piece of cloth filled with fallen petals, bemoaning the demise of the flowers. Lin Daiyu, who is said to be a reincarnation of the heavenly *Jiangzhu Xiancao* 絳珠仙草 (Crimson Pearl Flower), bewails the frailty and transience of the flowers, as well as of her own life, in an elegiac poem:[2]

花謝花飛花滿天，	The blossoms fade and falling fill the air,
紅消香斷有誰憐？	Of fragrance and bright hues bereft and bare.
遊絲軟系飄春榭，	Floss drifts and flutters round the Maiden's bower,
落絮輕沾撲繡簾。	Or softly strikes against her curtained door.
閨中女兒惜春暮，	The Maid, grieved by these signs of spring's decease,
愁緒滿懷無釋處。	Seeking some means her sorrow to express,
手把花鋤出繡閨，	Has rake in hand into the garden gone,
忍踏落花來複去。	Before the fallen flowers are trampled on.
⋯　　　⋯	

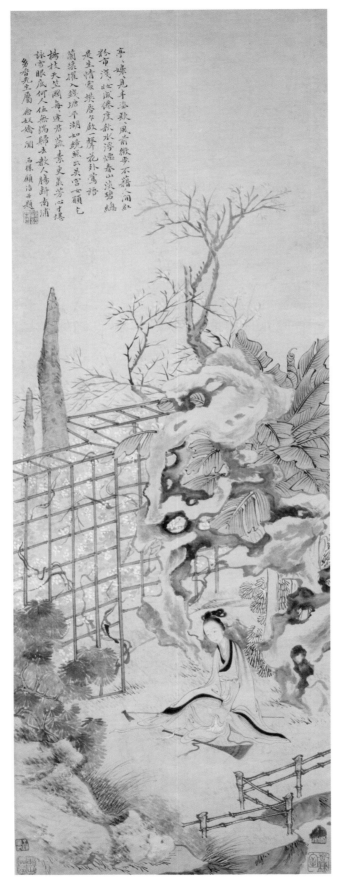

1 Gu Luo 顧洛 (1763 – after 1837)

 Hidden Meanings of Death

爾今死去儂收葬，	Can I, that these flowers' obsequies attend,
未卜儂身何日喪？	Divine how soon or late my life will end?
儂今葬花人笑癡，	Let others laugh flower-burial to see:
他年葬儂知是誰？	Another year who will be burying me?
試看春殘花漸落，	As petals drop and spring begins to fail,
便是紅顏老死時。	The bloom of youth, too, sickens and turns pale.
一朝春盡紅顏老，	One day, when spring has gone and youth has fled
花落人亡兩不知！	The Maiden and the flowers will both be dead.[3]

Death and love are always closely intertwined in reality or in art. Lin Daiyu's grieving response to her fleeting life, likewise, was triggered by an overwhelming sense of lovesickness. Her excessive concerns about getting old and dying in the poem foretell her premature death caused by love. The same sentiment of lost love is shared in Gu Luo's painting through the *ci* poem inscribed by the artist at the request of his patron:

亭亭嬝嬝，見丰姿，	So elegant and charming was her gait,
欵欵風前微步驟。	As she took a few gentle steps in the breeze.
不藉人間，紅粉市，	Without relying on the rouges of the market place,
淺淺妝成僊度。	She lightly made herself up in an immortal's guise.
⋯ ⋯	
更羨芳心，	With a soul capable of
才堪詠雪眼，	Singing praise to the snow,
底何人伍？	So aloof [were you], who could be your companion?
無端歸去，	Now you have gone,
教人腸斷南浦。	Leaving none but a broken heart at Nanpu![4]

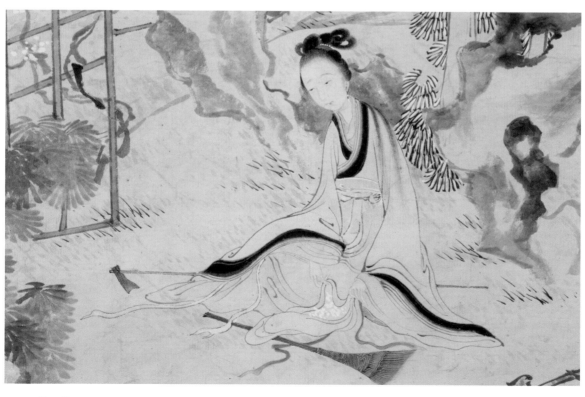

Detail

Another prime example of the subtle representation of death coupled with love is a handscroll painting entitled *Illusionary Images at the Xiaoxin* [Pavilion] (曉心夢景圖) by the little-known Qing dynasty artist Pan Xuefeng 潘雪峰 (fl. 18th C.) in the Papp collection [2].[5] The painting was commissioned by the scholar-official Wang Rubi 王如璧 (1743-1806) to make a pictorial record of himself in his estate. At the beginning of the scroll, Wang Rubi is shown sitting solemnly with a stern face in the upper story of the Xiaoxin Pavilion. A boy attendant is serving him tea and a rising cloud of incense smoke creates an atmosphere of quietude and serenity. As the handscroll is unrolled, there is a panoramic depiction of a natural scene with dozens of butterflies flying over the misty water. An unknown land inhabited by pine trees occupies the end of the composition. Despite a resplendent depiction in bright colors of the enchanting butterflies, the scene is saturated with emotions of sadness.

2 Pan Xuefeng 潘雪峰 (fl. 18th C.)

There are several inscriptions in the handscroll indicating that Pang Xuefeng's painting was done in the year 1794.[6] According to Wang Rubi's biographical account, that was a difficult time when his life became increasingly filled with grief.[7] Not long before the execution of the painting, Wang Rubi's official career had stumbled. Even worse, a year earlier, his son died followed by the passing of his wife within a few months. These bitter experiences, especially the tragic loss of loved ones, were undoubtedly immense blows to Wang Rubi, who, being an old man entering his twilight years, certainly had serious thoughts on the issues of death. He conveys such concerns in a subtle way in his poetic inscription on Pan Xuefeng's painting [3]:

丹青樹外有仙洲，	Beyond the painted trees lies the immortal isle.
高閣凌虛似舊遊。	The towering pavilion above mist brings back my memories.
鳳子三生來少海，	Three lives ago, I, Fengzi, had come to the Sea of Shao.
漆園一夢足千秋。	In the Lacquer Garden, I dreamed of eternity.
隙中靜覺春駒過，	Through a crack of space, I quietly sensed time fleeting.
花裏如逢綵燕留。	Amidst flowering plants, cheerful swallows beckon me to stay.
願借好詩長供養，	I would love to entice fine poems as offerings [to this scroll],
年年日暖午風柔。	Year after year, the sun is warm and the afternoon breeze mellow.[8]

The previous research by Ju-hsi Chou has pointed out that the poem, with an allusion to Zhuangzi's dream of butterflies, creates a fantasy world in which Wang Rubi could escape from the cruel reality of human sufferings.[9] However, the mention of the previous lives and immortality in the poem, together with the unusual depiction of the beautiful butterflies, adds extra drama and pathos to the painting.

The butterfly, whose caterpillar is earth-bound, metamorphoses from a pupa into an imago which casts off its skins before flying freely into the air. Its life cycle propels people to compare its transformation to the path of the human soul rising above earthly matters. The beautiful insect therefore symbolizes the soul, and is an emblem of death in many cultures. In the ancient Greek, the word for butterfly is *psyche*, which may also mean "soul." It is a common belief in China that the spirit or soul of a deceased person will become a butterfly. The Chinese term *diehua* 蝶化, which literally means "turning into butterfly,"

connotes death.[10] A famous Chinese love tale is about the tragic romance between two lovers, Liang Shanbo 梁山泊 and Zhu Yingtai 祝英台 of the Eastern Jin period, the so-called "butterfly lovers."[11] The story tells that they were not allowed to be together when alive, but after their deaths, the souls of the lovers turned into a pair of butterflies, flying together among the flowers forever, never to be apart again.

3 Detail

One of Sigmund Freud's interpretations of dreams, for instance, states that a young girl, harboring an unconscious wish for her brothers, sisters and cousins to die, dreamed repeatedly of them growing wings and flying away in the form of butterflies.[12] As a symbol of death, the butterflies in Pan Xuefeng's painting seem to be elaborately rendered to represent the souls of the dead. They are shown in groups like friends, in pairs like couples, or separately like lonely individuals. All of them are depicted in such great detail as if they were human beings with different characters [4 A and B]. Considering Wang Rubi's recent loss of his wife and son, these butterflies could be portrayed to represent the souls of his deceased family members, friends, or even the ones close to him in his previous lives.

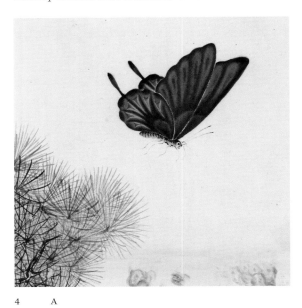 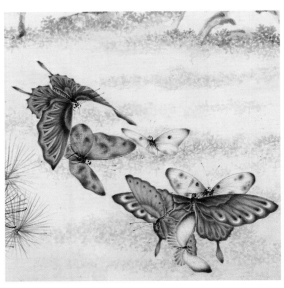

4 A 4 B

The association of the butterflies with death in Pan Xuefeng's painting is reinforced by the depiction of the misty water they are flying above. Like the River Styx in Greek mythology, the Chinese believe that the dead will enter the underworld realm called Huangquan 黃泉, which means "Yellow Springs." [13] The river in the painting, covered with a blanket of heavy mist, creates an atmosphere of mystery and melancholy. To the right of the river lies a garden terrace, on which two young boys are having fun viewing and playing with the flying butterflies. This reminds us of the innocent toddler in Li Song's *Puppet Play of a Skeleton*. The young boys in Pan Xuefeng's painting also demonstrate their ignorance about human mortality.

In contrast to the jubilant young boys, the figure of Wang Rubi in the upper story of the pavilion has a strained facial appearance [5}. Wang Rubi, who seems to be caught in the sad memories of his beloved wife and son, appears uninterested in the surroundings, turning outwards to cast a somber glance at the viewer. This frontal pose with a potential eye-engagement establishes a virtually continuous space as well as a psychic intercourse between the sitter and the beholder. The rendering of frontal figures in pictorial art is actually parallel to the grammatical form of the first person, the role of "I" in speech with its complementary "you." It is therefore appropriate for such figures to be symbols or carriers of a specific message.[14] In the case of Pang Xuefeng's painting, the artist ingeniously poses Wang Rubi as a frontal figure, suggesting an eye-engagement with the viewer so as to communicate some sense of the sitter's personal situation.

Hidden Meanings of Death

Pan Xuefeng's visual approach could in fact be treated by Wang Rubi as a *daowang shi* 悼亡詩 (mourning poem), a literary type which has a long tradition in China. One of the earliest examples can be seen in the *Shijing*, which bemoans the loss of a beloved one:

葛生蒙楚，蘞蔓於野。 The dolichos grows, covering the thorn trees; the convolvulus spreads all over the waste.

予美亡此，誰與獨處？ The man of my admiration is no more here; with whom can I dwell? – I abide alone.

…　　　…

冬之夜，夏之日。 Through the [long] nights of winter, through the [long] days of summer [shall I be alone],

百歲之後，歸於其室。 Till the lapse of a hundred years, when I shall go home to his chamber.[15]

Suffering the bereavement of the deaths of his wife and son, as well as the setback in his official career, Wang Rubi somehow found a way to relieve all the negative emotional afflictions by envisaging the land of bliss and immortality. In his poetic inscription, he mentions his visit in previous lives to the Sea of Shao, another name for Bo Sea 渤海, where immortals and the drug of deathlessness could be found on the legendary isles Penglai 蓬萊, Fangzhang 方丈 and Yinzhou 瀛州.[16] The memory of this supernatural experience, according to Wang Rubi, was provoked by the immortal isle beyond the painted trees and his presence at the storied pavilion, which are recorded in Pang Xuefeng's painting.

5　　Detail

Wang Rubi's inscription, in particular his mention of the *gaoge* 高閣 (towering pavilion) that brings back his memories of previous lives to visit Bo Sea, also relates Pan Xuefeng's painting to the traditional theme of *xianshan louge* 仙山樓閣 (Towers and Pavilions in Celestial Mountains). The depiction of palatial structures of towers and pavilions in paradisiacal landscape is essential for rendering the land of the immortals. This suggests the secluded yet comfortable life of the divine beings, who were believed to have preferred to reside in tall buildings. The *Shi ji* 史記 (Records of the Grand Historian) by Sima Qian 司馬遷 (145-90 BCE) quotes a statement by one of the trusted *fangshi* 方士 (masters of the methods) of Wudi 武帝 (r. 140-86 BCE), disclosing their habits:

公孫卿曰：「仙人可見，而上往常遽，以故不見。今陛下可為館如緱氏城，置脯棗，神人宜可致。且仙人好樓居。」[17]

Gongsun Qing said: "Immortals can be visible. When Your Majesty went, they were often frightened off. For this reason they were not seen. Now that Your Majesty can build mansions like those in the Goushi city, placing dried meat and dates, the divine beings then would come. Also, the immortals like to live in tall buildings."[18]

The immortals' preference for tall buildings was because they could reach the mist and clouds, consuming the wind and dew as food and drink to attain deathlessness, as indicated in the Daoist classic *Zhuangzi* 莊子.[19]

The representation of palatial structures in Chinese painting with the *xianshan louge* theme has traditionally required a refined and meticulous style characterized by the use of fine, and often straight-edged, brush lines in its execution. The term *jiehua* 界畫 (boundary painting) has been coined to specify this type of painting with a detailed and precise depiction of architectural forms, sometimes with the aid of a ruler.[20] An elaborate rendering of the *xianshan louge* theme with *jiehua* technique is shown in a painting by the 19th-century artist Su Renshan 蘇仁山 (1814-1850) in the Papp collection [6]. The work of monumental proportions was done by the artist in 1829 at the tender age of fifteen. Su Renshan mastered the demanding techniques in creating a fascinating landscape with strangely-shaped mountain peaks and extravagantly embellished palatial structures. Overflowing with a father's pride, Su Yinshou 蘇引壽 (1788-1862) added a long inscription on his prodigy son's painting, revealing more about the auspicious theme:

千門玉宇望中開，	A thousand doors to the jade firmament open under the full moon,
寫淂方壺樣子來。	This painting seeks to evoke the (mythic isle of) Fanghu.
陋巷半生嫌住久，	For half of my life I lived, alas, in a humble alley.
教兒筆下起樓臺。	So I taught my son to paint splendid towers and terraces.
樓臺籠樹樹籠煙，	These towers and terraces enclose trees, and trees enclose the mist.
真個壺中小洞天。	Truly this is like a small cosmos in a (tea) pot.
細認綠陰滿院落，	With care, I can discern the green shades that fill the courtyard.
似曾清夢到游仙。	Have I not visited this immortal land in my dream?[21]

6 Su Renshan 蘇仁山 (1814-1850)

Su Yingshou writes about the legendary mountain-island Fanghu, which is one of the abodes of immortals in the Bo Sea also known as Fangzhang. Even though contacts with the immortals were apocryphal and ways to reach their divine lands of bliss were elusive in reality, the visual representation of *xiangshan louge* still appealed greatly to the folks, who could seek comfort and consolation when facing the inevitability of human mortality. An album leaf painting by the 19th-century artist Wu Tao 吳滔 (1840-1895) in the Papp collection shows a precariously perched, oddly-shaped rock formation rising forcefully from surging waves, probably a depiction of the mythic mountain-island of the immortals [7].

7 Wu Tao 吳滔 (1840-1895)

Another example of the *xiangshan louge* theme is a 16th-century painting by an anonymous Zhe school artist in the Papp collection [8]. It depicts no ordinary landscape but a misty mountain scene of paradisiacal elegance and otherworldly allure. Cloaked behind precipitous boulders, the lofty terrace and palatial pavilion suggests the abode of the immortals, who are shown leisurely enjoying their eternal blissful lives in mountains. It was a common belief that immortals are fond of playing board games of *liubo* 六博 and *weiqi* 圍棋 to make their time pass pleasantly.[22]

8 Anonymous Zhe school artist

9 Zhao Changguo 趙昌國 (fl. 16th C.)

A copy of Dai Jin's 戴進 (1388-1462) work entitled *Immortals Playing Weiqi in the Autumn Mountains* by the little known artist Zhao Changguo 趙昌國 (fl. 16th C.) in the Papp collection illustrates the noble entertainment of chess for those who could shuffle off their mortal coils [9].

Mountains are sacred and vital in Chinese religions because the soaring peak has been regarded as the axis that connects the earth to heaven. In Daoism, mountains were sites where adepts could encounter divine beings and find the herbs and minerals to compound the elixir of immortality. The concept and practice of *rushan* 入山 (entering the mountains) has a long tradition in China. Daoist adepts entered the mountains to meditate and purify their minds, and most importantly to undertake the pursuit of longevity and immortality. The *Shenxian zhuan* 神仙傳 (Biographies of the Divine Immortals) by Ge Hong 葛洪 (284-363) of the Eastern Jin period recounts the legendary Han dynasty immortal Wang Yuan 王遠 (fl. 146-195), who renounced public life to cultivate the Dao in the mountains.[23] Wang Yuan became an archetypal Confucian-turned-Daoist-turned-immortal and he inspired countless intellectuals in later centuries to withdraw from their political and social engagements to dwell in secluded mountains in order to devote themselves to self-cultivation and immortality pursuit.

Ge Hong himself, who was learned in Confucian scholarship but turned to Daoism, also retired from public life in his later years to live in the Luofu 羅浮 Mountains to perfect his immortality quest both theoretically and practically. He and his family established a religious legacy that enjoyed high esteem among intellectuals over the centuries.[24] The semi-legendary immortal Lu Dongbin 呂洞賓 (b. 796) followed in the same footsteps to retreat to the mountains to undertake the quest for immortality. He became the acknowledged patriarch of both Nanzong 南宗 (Southern Lineage) and Quanzhen 全真 (Complete Perfection), the Southern and Northern lineages of Daoism, as well as one of the famous *baxian* 八仙 (Eight Immortals).[25] As a beau ideal of human-turned-immortal, Lu Dongbin became a popular subject in art and literature.

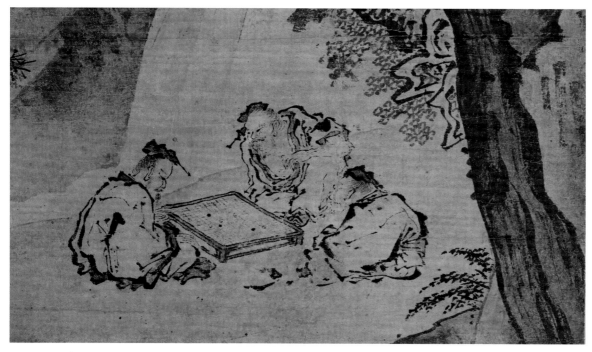

9 Detail

A two-fold silk screen by the Ming court artist Wang Zheng 王政 (fl. 15th C.) in the Papp collection depicts the Daoist immortal Lu Dongbin and his student Han Xiangzi 韓湘子 (b. 794) in a fluent and expressive style associated with the Zhe school [10 Left and Right].[26] Lu Dongbin is shown on the right panel sitting under a tree with his eyes almost shut, which alludes to the story that he attained the Dao in his dream with the help of Zhongli Quan 鍾離權, another immortal from the *baxian*. On the left panel, Han Xiangzi is seated in a similar pose as his teacher, playing the musical instruments *yugu* 漁鼓 (drum) and *jianban* 簡板 (clappers) to perform the Daoist ballad to propagate the religious beliefs. The pairing of the two figures into a two-fold screen thus conveys an underlying message that the blessing for long life and immortality can be passed from one generation to the next.

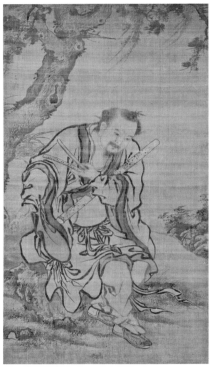

10 Left Right
Wang Zheng 王政 (fl. 15th C.)

The Chinese character for immortal is *xian* 仙, which is composed of two pictographic elements, *shan* 山 (mountain) and *ren* 人 (man).[27] Therefore it appears that the word was originally applied to those who retired from the world to live a reclusive life in the secluded mountains. The Chinese fascination with a secluded life in mountains played an important role in its art and culture, contributing to an excessive emphasis on landscape in its painting tradition. A work by the 18th-century scholar artist Qian Feng 錢澧 (1740-1795) in the Papp collection encapsulates the profound symbolism of mountains related to the Daoist quest for longevity and immortality [11]. It depicts a tiny figure of a recluse, who is walking all alone with the aid of a long staff, entering the mountains through a narrow and winding path to quest for longevity and immortality. Executed in ink on paper with sophisticated texture strokes and foliage dots, Qian Feng creates a poignant landscape of enchanting quietude and beauty.

Hidden Meanings of Death

11 Qian Feng 錢灃 (1740-1795)

Above the cloud-encircled peaks on Qian Feng's painting, a large empty space is occupied with three inscriptions. The one on the right was inscribed by the artist in a rigid style of standard script, which gives the title *Wansong tu* 萬松圖 (Painting of Ten Thousand Pines). The tradition of the *wansong* theme can be traced back to the Song dynasty. According to the *Qinghe shuhuafang* 清河書畫舫 (Qinghe Painting and Calligraphy Barge) by the Ming collector and connoisseur Zhang Chou 張丑 (1577-1643), Mi Fu once painted the *Ten Thousand Pines at Nan Shan*.[28] The symbolic meaning of Mi Fu's work is pronounced because both the pine and *Nan shan* 南山 (South Mountain) are common symbols of longevity and immortality.[29]

As an evergreen tree of imposing stature and strong vigor, the pine has long been regarded as a token of long life in Chinese culture. In the Daoist tradition, pine seeds and rosin are potent ingredients that could confer longevity and physical immortality. For instance, the legendary Jin dynasty Daoist Huang Chuping 皇初平 (b. 328), also known as Chisong Zi 赤松子 (Master Red-Pine), attained immortality with his brother by ingesting pine rosin and *fuling*.[30] Given the symbolism of the pine, an artwork representing the tree was deemed as an ideal gift that delivered a blessing for long life in traditional China. The *Qinhe shuhuafang* records that the Ming scholar artist Shen Zhou 沈周 (1427-1509) brushed two paintings of ten thousand pines, which are believed to have served for such purpose.[31] Qian Feng's inscription also remarks that his work was done as a gift for the senior scholar official Xie Yong 谢墉 (1719-1795), one of the most respected figures at the Qianlong court who was appointed as the chief investigator at the imperial examinations and famous for nurturing young talents. The dedicatory poem by the artist explicates the meaning of the theme with reference to Daoist ideas and practices of immortality:

欲恭守黑此機關，	He intended to follow the secret rule of "keeping to the dark;"
讀罷黃庭半日閒。	After reading the *Huangting*, he was free for the rest of the day.
撒手出門隨意去，	Without earthly concerns, he walked out the door;
一聲長嘯萬松間。	His sustained whistle passes through the ten thousand pines.

Ju-hsi Chou's previous research has pointed out the Daoist sentiment in the poetic lines, noting that the term *shouhei* is taken from the *Laozi* 老子.[32] In the poem, Qian Feng also mentions the *Huangting jing* 黃庭經 (Scripture of the Yellow Court), which is one of the most important Daoist texts about the nourishment of life in the *neidan* 內丹 (inner alchemy) tradition. But most importantly, the term *changxiao*, which literally means "sustained whistle," in fact refers to a Daoist practice of exhaling *qi* to attain deathlessness. The *Xiao zhi* 嘯旨 (Purport of Whistle) by the Tang scholar Sun Guang 孫廣 (fl. ca. 765) elucidates the concept and technique:

> 夫氣激於喉中而濁，謂之言；激於舌而清，謂之嘯… 嘯之清，可以感鬼神，致不死…
> 出其嘯善，萬靈受職。斯古之學道者哉！[33]
>
> The *qi* that works inside the throat is turbid, which is called *yan* (speech); and the *qi* that works on the tongue is clear, which is called *xiao* (whistle)… The clarity of whistle can move all the spirits and can confer deathlessness… The good result of whistling can benefit tens of thousands of beings. This is what the ancient learning of the Dao is!

Another poetic inscription by the scholar artist Wang Zhizuo 王之佐 (fl. ca.1782) at the upper right of the painting reveals the true intention of whistling, which aims to achieve the transcendental state of being and immortality:

山水長留文字緣，	The tie between the painting and poem will endure.
一聲清嘯學飛僊。	Blowing a clear whistle, he learned to be a flying immortal.
西湖多少尋春客，	How many of those who travel to the West Lake in spring,
若箇能將畫意傳？	Can truly understand the message of the painting?[34]

The tiny figure depicted in Qian Feng's painting is, therefore, not just strolling into the mountains but also practicing whistling amid a grove of pines for the sake of longevity and immortality. There are other Daoist pictorial elements presented in the painting, such as the rendering of the auspicious clouds in the shape of magic fungi to further accentuate the wish for long life.

To live a reclusive life in mountains was not easy or safe in the past, as warned by Ge Hong in his *Baopu zi neiwai pian* 抱朴子內外篇 (The Master Embracing Simplicity Inner and Outer Chapters).[35] But the practice with its Daoist implications became popular since the Song dynasty, which attracted great artistic interest in representing the joyful leisurely life in mountains. Two leaves from an album done by the Qing artist Shangguan Zhou 上官周 (1665- ca.1750) in the Papp collection exhibit the recluses' delightful self amusements in the mountain caves [12]. The two paintings, entitled *Playing Zither for a Receptive Audience* and *Holding a Wine Cup While Smiling at a Planter of Flowers* respectively, are both related to the Daoist theme of immortality for their depictions of the caves.

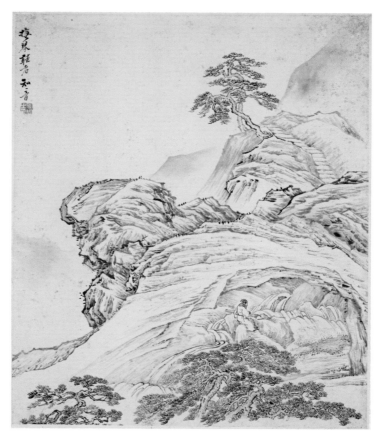

12 Shangguan Zhou 上官周 (1665- ca.1750) Leaf C

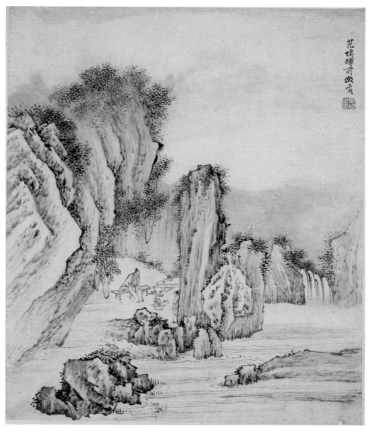

12 Leaf H

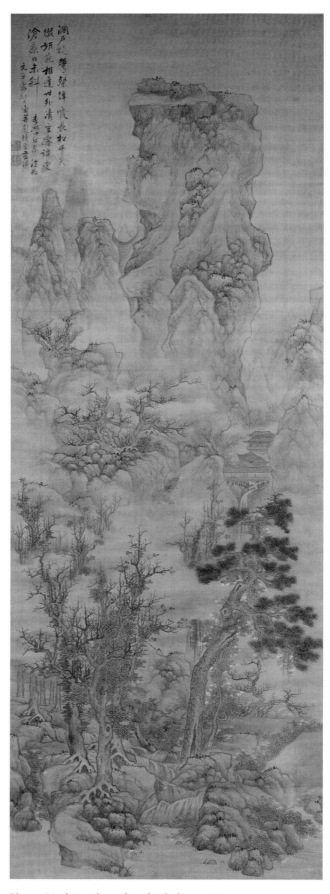

13 Landscape from the school of Lan Ying

Hidden Meanings of Death

The mysterious caves call to mind the Daoist idea about the blissful semi-paradise known as *dongtian* 洞天 (cave-heaven) that lies hidden behind the walls of rock in mountains. In ancient Chinese language, the character *dong* 洞 had the same meaning as *tong* 通 (to pass through or connect).[36] Therefore the term *dongtian*, which is phonetically similar to *tongtian* 通天, denotes "passing through or connecting to heaven."[37] The otherworldly imaginations about caves formed an important ingredient in the Daoist tradition. According to the *Yunji qiqian* 雲笈七簽 (Seven Tablets in a Cloudy Satchel) compiled by Zhang Junfang 張君房 (ca.961-ca.1042) of the Song Dynasty, the thirty-six sacred mountains each has its cave-heaven, where a mysterious passage leads to the world of the blessed.[38]

A well-known exemplification of this Daoist concept is the *Taohua yuan ji* 桃花源記 (Peach Blossom Spring) conceived by Tao Yuanming 陶淵明 (365-427):

林盡水源，便得一山。山有小口，髣髴若有光，便捨船從口入。初極狹纔，通人復行數十步，豁然開朗…[39]

At the end of the river and trees there was a mountain. The mountain had a cave, which seemed to have light inside. He then left the boat and went through the entrance. At first it was very narrow, but after continually walking tens of paces, it became bright and open...

It was not the darkness of the cave that was intriguing, but rather the shimmering light at the other end which promised a new earthly paradise where human sufferings and death no longer exist. A pictorial interpretation of the *Taohua yuan* can be seen in a vertical landscape from the school of Lan Ying [13]. The painting exhibits a dream-like scene with strangely-shaped rock towers and mountain tops. All the richly textured, organic landscape forms writhe and thrust upward to the height of the dominant peak in the background. There is a strip of waterfalls and some multi-storied palatial structures hidden behind the boulders on the middle right. In the foreground, some gnarled trees rise magnificently on the river-banks. The whole picture, rendered in an expressive brush style, is imbued with a mystifying and surreal atmosphere that conforms to the fantasy of the elusive utopian paradise where the chosen aspirants could join the immortals to live an eternal joyful life.

An even more elaborate treatment of the *Taohua yuan* theme is a long handscroll by the late Ming and early Qing Suzhou artist Wen Nan 文柟 (1596-1667) in the Papp collection [14]. In Wen Nan's painting, the dynamic pictorial representation, with its meticulous delineation of landscape and architectural images, creates an idealized panoramic scene detached from the dusty world. His turbulent landscape forms heave and thrust against each other, twisting and piling up into a mountain screen of compelling strangeness and charm. The whole picture is dominated by a winding movement replete with the vital force of organic life. Colored in light blue and green mineral pigments, Wen Nan's handscroll also follows the *qinglu shanshui* 青綠山水 (blue-and-green landscape) tradition in which his forefathers Wen Zhengming, Wen Peng 文彭 (1498-1573) and Wen Boren 文伯仁 (1502-1575) excelled.

The use of mineral pigments of blue and green in landscape painting has a long tradition in China. The Tang artist Li Sixun 李思訓 (651-761), nicknamed General Li, and his son Li Zhaodao 李昭道 (fl. 690-730) have been considered as the precursors of the lively *qinglu shanshui* style. Blue and green colors have traditionally been used to symbolize nature and its embodied attributes, such as life and youth.[40] The Daoist obsession with blue and green colors is therefore logical and natural considering their symbolic connections with life.[41] But even more fascinating is the association between the chemical properties of the mineral pigments with Daoist alchemy. The blue and green pigments are made from the minerals azurite and malachite, which were believed to have longevity-conferring properties and were therefore important ingredients in compounding elixirs of immortality.[42]

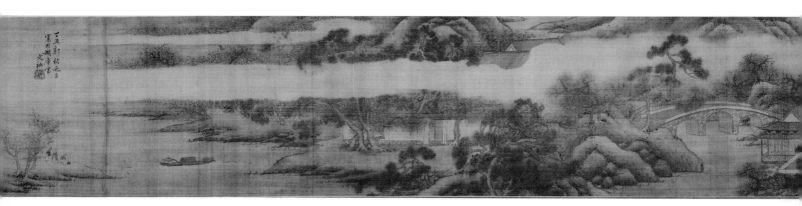

14 Wen Nan 文柟 (1596-1667)

Detail

Detail

Detail

高歌
太白問月自白
問自月白句
詫句髮
青春歌
青春不髮
白髮固
及夫捲連酒豪
波吸連
月問
老老
六十年
更問
中秋
十餘四
賞與汝正
諸君正
汝同賦
低正出索
畫小
景屏
書尾于
長州石
白沈有書
翁周于竹
之平庄
安亭

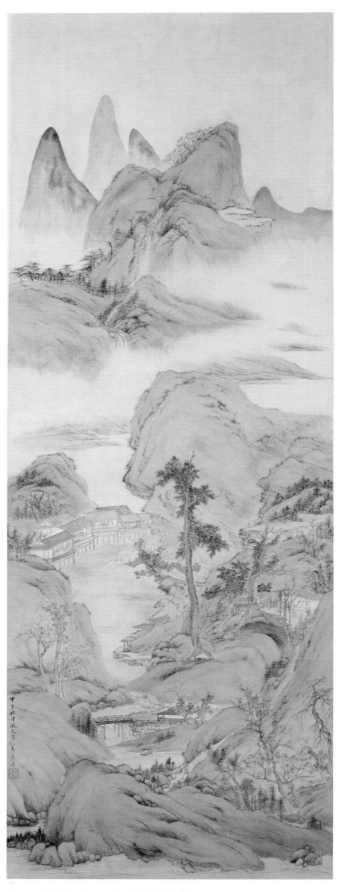

15　　Liu Yanchong 劉彥沖 (1807-1847)

Hidden Meanings of Death

16 Shen Zhou

A landscape painting by the Qing artist Liu Yanchong 劉彥沖 (1807-1847) in the Papp collection exemplifies the enchanting qualities of the *qinglu shanshui* style [15]. Enlivened by the shining colors of blue and green, it exhibits an attractive landscape setting that exudes the vivacious spirit of the spring season. A tiny figure of a recluse is shown walking all alone through a narrow path into the riverside mountains. The humble dwellings along the riverfront integrate harmoniously with their natural surroundings, which suggest an ethereal utopia reminiscent of the *Taohua yuan*. Liu Yanchong's inscription expresses his indebtedness to a work by Wen Zhengming, who excelled in the use of blue and green pigments, especially in rendering the theme of *Taohua yuan*.[43]

Another intriguing work in the Papp collection that is related to the Daoist concept of immortality is a handscroll painting entitled *Watching the Mid-Autumn Moon at Bamboo Villa* by Wen Zhengming's teacher Shen Zhou [16].[44] The painting is of modest dimensions, measuring two and a half feet in height by seven and a half feet in width. In the middle of the composition, three gentlemen are seated inside the Ping'an Ting 平安亭 (Pavilion of Peace), a simple thatched structure located on a gentle slope within Shen Zhou's Youzhu Zhuang 有竹莊 (Bamboo Villa). The figures are watching the full moon on the upper left, celebrating the Mid-Autumn Festival. There are small stands of bamboo rising on the right and beyond the pavilion flows a mild river, over which a rustic bridge connects the riverside terrace to a land covered by trees and rocks on the left.

16 Detail

16 Detail

In Shen Zhou's painting, despite the festive celebration of the Mid-Autumn moon, the gathering scene is dominated by feelings of sadness and grief, reflected in the artist's poem colophon in the Papp handscroll [16, 17]:[45]

少時不辯中秋月，	In my youth, I saw the Mid-Autumn moon,
視與常時無各別。	As no different from any other moon.
老人偏與月相戀，	In old age, I grew fond of it.
戀月還應戀佳節。	Loving the moon means also to love the fine autumn feast.
老人能得幾中秋，	How many more Mid-Autumn feasts can an old man enjoy?
信是流光不可留。	In truth, time flows on and cannot be detained.
古今換人不換月，	We know men come and go but not the moon.
舊月新人風馬牛。	The old moon shines on newcomers with indifference.
壺中有酒且為樂，	If there is wine in the pot then let us be merry;
杯巡到手莫推却。	And never refuse when the cup comes to you.
月圓還似故人圓，	[Tonight] the moon is full and the friends are reunited.
故人散去如月落。	When we part, the moon will also wane.
眼中漸覺少故人，	As my eyes have seen fewer old friends,
乘月夜遊誰我嗔。	Throwing caution aside, I'd dally long under the moonlight.
高歌太白問月句，	I shall sing aloud Li Bai's "Asking the Moon."
自詫白髮欺青春。	But my white hair startles me, robbing me of my youth.
青春白髮固不及，	If youth and white hair cannot be paired,
豪捲酒波連月吸。	May my surging spirit drink up the ocean of wine and the moon (reflected in it).
老夫老及六十年，	This old man has lived for sixty years of life.
更問中秋賒四十?[46]	Can I ask the Mid-Autumn [moon] to lend me forty more? [47]

17 Detail

Hidden Meanings of Death

Shen Zhou's concern about human mortality is evident in the poetic lines and it changes the painting from a depiction of a happy reunion of friends enjoying the Mid-Autumn moon to a melancholic scene dealing with the issues of death – both the loss of departed friends and the transience of his own life.

In the finishing lines of the poem, Shen Zhou indicates that he was sixty when the memorable Mid-Autumn gathering was held at his estate Youzhu Zhuang. The artist's age in this case is essential for discussing his attitude towards death because as people enter their twilight years, their sense of physical mortality usually becomes much stronger. In fact Shen Zhou's worry about death gradually intensified since his middle age when he started to face the aging of his body as well as the passing of his family members and friends.[48] Shen Zhou expresses such concern in a poem he composed for his fifty-fifth birthday:

百歲今過五十五，	[If I can live] a hundred years, now I already passed fifty-five,
餘生望滿亦茫然。	To live out the remaining years of my life, I have no idea.
已多去日少來日，	The passed days are getting more and the coming days less,
卻誤添年是減年。[49]	But I mistook that to add years to my age is to deduct years [of life].

When Shen Zhou was sixty, he suffered the loss of his wife Chen Huizhuang 陳慧莊 (1423-1486) after their forty-two years of happy marriage.[50] Not only did he face the issue of death with unprecedented pain but he might also have associated his own inevitable fate of mortality with this bereavement, especially since the couple had the same birthday on the twenty-first day of the eleventh lunar month.[51] Chen Huizhuang passed away in the fourth lunar month of 1486, and this was the reason that Shen Zhou expressed a deep concern about death in the poem colophon in the Papp handscroll, which was done at the Mid-Autumn festival in the eighth lunar month that year.

Shen Zhou frequently used the Mid-Autumn moon as a metaphor to convey his sentimental attachments to departed family members or friends, and above all to express the deep concern about his own mortality. Contemplating the ephemerality of life, he wrote with mixed emotions at this particular festival:

愛是中秋月滿湖，	Oh my lovely Mid-Autumn moon, brightly shining on the lake;
儘貪佳賞亦須臾。	For the fleeting delightful scene, steal a moment to enjoy.
固知萬古有此月，	We know this moon will last forever,
但恐百年無老夫…[52]	But this old man just cannot live to a hundred…

Like the poetic lines inscribed in the Papp handscroll, another poem was composed by the artist on the occasion of a Mid-Autumn banquet to reflect on the transience of human life:

萬古一中秋，	Since time began, there is a Mid-Autumn;
月亦同萬古。	And likewise, the moon also lasts forever.
陰晴與憂樂，	Bright or dim, happy or sad;
中有時事阻。	Always are there obstacles in life.
月本天中行，	The moon moves in the sky,

與人相惘然。	It should not be relevant to man.
今夕適中秋，	Tonight is the Mid-Autumn,
浮雲忌清圓。	The bright full moon is envied by floating clouds.
萬事有不齊，	Nothing can be perfect,
即之譬人月。	This is why the moon resembles mankind.
人情閒憂樂，	Man has emotions of joy or sorrow,
月亦間圓缺。	And the moon also waxes or wanes.
… …	
呼月對白頭，	I shout at the moon, which matches my hoary-haired head.
尚能幾中秋。	How many more Mid-Autumns can I enjoy?
人生無萬古，	No Human being can live an eternal life,
月但伴荒丘。[53]	But the moon always shines over the desolate hill.

Shen Zhou's comparison of the fleeting life to the eternal moon, which is also posed in the poem colophon, shows his indebtedness to the profound utterance in "Asking the Moon with Wine in Hand" by the Tang poet Li Bai:

青天有月來幾時？	When did the moon first come on high?
我今停杯一問之。	I stop drinking to ask the sky.
人攀明月不可得，	The moon's beyond the reach of man;
月行卻與人相隨。	It follows us where'er it can.
… …	
今人不見古時月，	We see the ancient moon no more,
今月曾經照古人。	But it has shone on men of yore.
古人今人若流水，	Like flowing stream, they passed away;
共看明月皆如此。	They saw the moon as we do today.
唯願當歌對酒時，	I only wish when I drink wine,
月光長照金樽裡。[54]	Moonlight dissolves in my goblet mine.

With its perfect circular form, the full moon is usually associated with harmony, peace, completeness and unity. But a bitter aura also hangs about the full moon – waning follows waxing, which stirs thoughts of loss and separation, of decline and death. The idea of seeing imperfections or deducing negative consequences from something in its perfect state or form can be traced back to ancient Chinese philosophy. The classical text *Yi jing* 易 經 (Book of Changes) says:

日中則昃，月盈則食，天地盈虛，與時消息，而況於人乎！況於鬼神乎！[55]

When the sun has reached the meridian height, it begins to decline. When the moon has become full, it begins to wane. The [interaction of] heaven and earth is now vigorous and abundant, now dull and scanty, growing and diminishing according to the seasons. How much more must it be so with [the operations of] men! How much more also with spiritual agency!

The full moon, especially the Mid-Autumn moon, is a popular theme in Chinese painting. It has often been represented in contexts that draw on its seasonal associations where ideas about past and present, vigor and decline, life and death intersect. For

instance, the *Tangchao minghua lu* 唐朝名畫錄 (Record of Celebrated Painters of the Tang Dynasty) by the Suzhou scholar-official Zhu Jingxuan 朱景玄 (ca.785-ca.848) states that the court artist Zhang Xuan 張萱 (fl. 713-741) worked on the "painting of Moon-Watching, which was filled with melancholy brooding." (望月圖，皆多幽思。) [56]

Shen Zhou shared with Zhang Xuan the pervading melancholy engendered by the full moon in some of his paintings and poems. Once he wrote of the sorrowfulness and helplessness under the full moon:

半滿清光今夜月，	Tonight the moon is just half of its brightness,
已迫中秋。	And the Mid-Autumn is almost here.
有酒且消愁，	If wine is available, my sadness can be relieved;
無酒還休。	If there is no wine, I can only give up.
百年人月兩悠悠，	[For a life time of only] a hundred years, both man and the moon look gloomy,
明月催人人易老。	The bright moon moves people, and people easily get old.
老上人頭。[57]	Age shows up on one's head.

Shen Zhou was said to have painted the *Pavilion at Heavenly Lake under the Moon* and *Chatting in the Autumn Pavilion under the Moon*, which have not survived.[58] His painting in the Papp handscroll displays a similar representation of the images of pavilion and moon. The artist portrays a gathering in an isolated pavilion under the full moon, with no sign of human habitation around but an immense space of darkness and emptiness that suggests a poetic autumnal mood.

The Pingan Ting is indeed a site carefully chosen for the Mid-Autumn gathering in Shen Zhou's painting. For centuries Chinese poets and painters have used the pavilion to bring out the theme of farewell in their works because in the past it was the place where people saw their friends off and exchanged parting cups.[59] As an emblem of separation laden with grief and loneliness, the pavilion is fully employed by Shen Zhou to cherish the memory of his old friends, especially those departed, at the Mid-Autumn Festival in his painting. According to the lines in the colophon, the three figures closely placed together inside the Pingan Ting might not suggest the exact number of the guests attending the particular gathering in 1486.[60] In fact the rendering of the pavilion with quite an empty space inside alludes to the situation that many of Shen Zhou's friends had already passed away by the time of the gathering, including his beloved wife. Chen Huizhuang, who died just four months before the festival, had been regarded by the artist as his best friend.[61]

Grieved by the separation and death of his "old friends" at the Mid-Autumn gathering, Shen Zhou employs not only the pavilion but other symbolic images to convey his deep concern about the mutability of human existence and the impermanence of the physical world in his painting. His depiction of a crude bridge shaded by a willow tree on the lower left also suggests the emotional repercussions of separation. It was customary in traditional China to bid farewell at the bridge, snapping the willow twig as a symbolic gesture of heartbreaking separation.[62] The symbolism of the so-called *zheliu* 折柳 (snapping willow twigs) is replete with emotional implications related to separation.[63] As an elegant plant with soft, slender twigs swaying in the wind, the willow suggests imaginative themes in China, especially those linked with women and sex.[64] In Shen Zhou's painting, the artist might also have associated the willow tree with his deceased wife.

Shen Zhou's rendering of the Mid-Autumn moon on the upper left of the painting further evokes the memories of his wife. As the moon, according to Chinese cosmology, is a female element and the symbol of *yin*, the Mid-Autumn Festival is closely associated with women. At the eve of the festival an altar was built out-of-doors and the women in the family would carry out their duty to worship the moon in traditional China.[65] Shen Zhou certainly harbored a profound sense of loss and grief at the particular moment of Mid-Autumn Eve when he noticed that his wife did not and could never again perform the moon observance for the family. The emotional predicament caused by Shen Zhou's poignant laments over his newly deceased wife as well as his concern about human mortality, however, is resolved ingeniously through the depiction of a special Daoist symbol.

In Shen Zhou's painting, the central figure is holding an object in his right hand inside the Pingan Ting [18]. The object, in spite of its almost impeceptible size and shape, is of paramount importance in deciphering the hidden message of the work. At first glance, it looks like a wine cup for toasting the full moon with literary allusion to Li Bai's poem, which is mentioned in the artist's colophon.[66] This assumption, however, becomes dubious upon closer examination of the image, whose outline in fact has a grass-like plant form. It is also unlikely that the central figure is holding a cup in salute to the moon without active participation of his two partners. In light of Shen Zhou's Daoist inclination and his interest in the ideas of immortality, a different interpretation of the motif is presented.[67] As a symbolic representation of the quest for immortality, Shen Zhou pictured himself in the painting as the central figure holding in his right hand the magical plant *zhi* 芝 (*Ganoderma lucidum*).[68]

Zhi or *lingzhi* is a woody fungus deep brown in color with a lacquer-like sheen that grows at the roots of trees in temperate zones. Since ancient times the Chinese have believed that "*zhi* is a divine plant." (芝‧神艸也。)[69] The magical powers of the plant are recorded extensively in ancient texts ranging from historical accounts to literary writings, from religious scriptures to *materia medicas*.[70] In the *Shi ji*, for instance, Sima Qian records

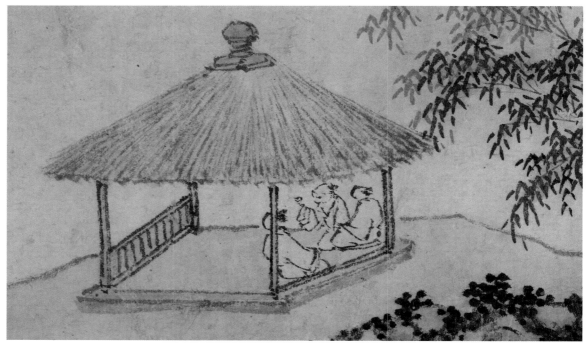

18 Detail

Hidden Meanings of Death

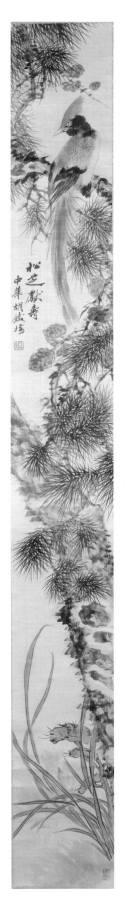

the appearance of the auspicious *zhi jiujing* 芝九莖 (*zhi* with nine stalks) in the Han palace at Ganquan 甘泉 and Wudi's dispatch of his necromancers to search for the magical plant.[71] The *Shennong bencao jing* 神農本草經 (Classics of Shennong's Materia Medica), datable to the Han Dynasty, also lists five kinds of *zhi* among the *shangyao* 上藥 (superior medicines) and points out that their "long-term consumption can make the body lighter, prevent old age, prolong life span, and attain immortality." (久食，輕身、不老、延年、神仙。)[72]

The symbolism of *zhi*, which bespeaks great health, longevity, and even immortality, was well established in the Han period.[73] There was an explosion of interest in this magical plant in the succeeding dynasties.[74] By the Ming period, the beliefs of the miraculous potency of the plant had been so deeply embedded in Chinese culture that *zhi* became one of the most popular subject matters in visual arts. For instance, the auspicious meaning of the magical plant is illustrated in a painting entitled *Pine and Fungi Celebrating Long Life* by the late Qing artist Hu Zhang 胡璋 (1848-1899) in the Papp collection [19].

Another piece from a set of eight hanging scroll paintings in the same collection by the late 19th and early 20th century artist Lu Hui 陸恢 (1851-1920) also employs the symbolism of *zhi* and cypress to deliver a blessing for long life on the occasion of his patron's birthday [20].[75]

For the Daoists, the magical plant *zhi* is an elixir of immortality which can be found in the legendary isles of the blessed or the sacred mountains. Ge Hong points out that there are several hundred kinds of *zhi* with longevity-benefiting properties and "these various *zhi* can often be found in famous mountains." (此諸芝，名山多有之。)[76]

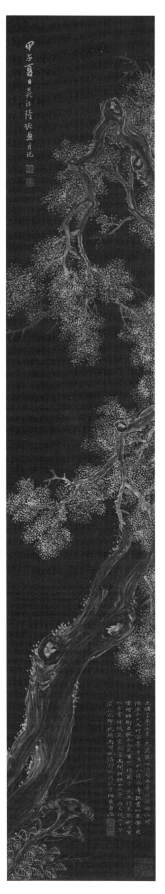

19 Hu Zhang 胡璋 (1848-1899)

20 Lu Hui 陸恢 (1851-1920)

Fascinated by the idea of the magical plant, many Chinese painters have created fantastic pictures of Daoist adepts gathering *zhi* in the mountains. The posture of grasping a stalk of *zhi* in the hand, which is called *caizhi* 採芝 (plucking *zhi*), has been a distinctive representation of the quest for immortality in China.[77] The depiction of *caizhi* has a long iconographic tradition in Chinese pictorial art.[78] The depiction of the *zhi*-grasper became popular in the Tang period. According to the *Xuanhe huapu* 宣和畫譜 (Xuanhe Painting Catalog), Yan Lide 閻立德 (d. 656) and Li Sheng 李昇 (fl. early 10th C.) both painted *Taishang [Daojun] Plucking Zhi*.[79] During the Five Dynasties period, artists like Dong Yuan and Gu Deqian 顧德謙 (fl. 960-975) also worked on the same theme.[80] Although these paintings do not survive, the iconography of the theme is well preserved in the *Sancai tuhui* 三才圖繪 (Tripartite Picture Assembly), in which *caizhi tu* 採芝圖 (painting of plucking *zhi*) is listed as one of the most common themes in painting.[81]

The use of the term *caizhi* should be further examined in order to better understand the evolution of its iconography in the history of Chinese painting. In the early paintings on this theme, artists depicted Daoist figures plucking and grasping *zhi* in the mountains. For instance, Dong Yuan's 董源 (d. ca.962) such work shows "blue mountains enveloped in the clean white clouds, in which a Daoist adept puts the spade at the cavern entrance plucking *zhi*." (青山縹緲，白雲瑩净，道人置鍤洞口採芝。)[82] However, most of the Ming and Qing paintings in the scholar-artist tradition rendered the theme differently by presenting the figure, either a Daoist adept or a scholar, holding the magical plant in possession in one hand and raising it up to show off like a precious prize. Shen Zhou followed this new iconographic representation in portraying himself as a *zhi*-holder in the Papp handscroll.

Like the metaphorical meaning of holding a key in the hand, the magical *zhi* became a symbol which specifically provided people with access to immortality in traditional China. This idea is revealed in a quatrain by the Song poet Lu You 陸游 (1125-1210):

何用金丹九轉成？　　　Why need I the reverted elixir in nine cycles?

手持芝草已身輕。　　　Holding the *zhi* in the hand already made my body lighter.

祥雲平地擁笙鶴，　　　The auspicious clouds suddenly embrace the singing cranes,

便自西山朝玉京。[83]　　And I head to the Jade Capital from East Mountain.

Shen Zhou also addresses the metaphorical concept of the plant, noting his grasping of the key to immortality by "holding the *zhi*, calling the white deer, and planting bamboos to attract the blue *luan* bird." (把芝呼白鹿，種竹引青鸞。)[84] The concept was also adopted into the *neidan* tradition, as demonstrated in the annotation of the *Huangting jing* by the Jing dynasty Daoist Liu Chuxuan 劉處玄 (1147-1203):

乃見玉清虛無老，上達玉清，中明黃老。體同太虛，手擎芝草。可以迴顏填血腦。　和血固精，調氣順神。煉真合道，乃可全真。[85]

Then one can see the elder of Yuqing Xuwu by ascending to the Jade Clarity and realizing the Huang-Lao. One's body is in unity with the Great Emptiness, and the hand raises the *zhi* plant. One's complexion will be restored with the look of the youth and the blood, brain, and marrows will be abundant by harmonizing the blood and strengthening the essence, regulating the breath and pleasing the spirit. One who practices the True Origin to be one with Dao can complete the perfection.

Liu Chuxuan used the term *qing zhicao* 擎芝草 (raising *zhi* plant) to specify the prize-winning gesture of showing off the key to immortality, thus suggesting the realization of the Dao. This concept with its associated term was also vital in the immortality practices of the Quanzhen sect. Wang Zhe 王嚞 (1113-1170), the founder of this Daoist sect, explicates in his lyric poem:

弟子重陽，侍尊玄妙。手內擎芝草。歸依至理，就中偏許通耗。至今自在逍遙，金丹傳得，一點靈明好。[86]

The student Chongyang serves deferentially the Mysterious Wonder. I raise the *zhi* plant in my hand. And I grace the ultimate truth, choose the middle path, devote to my wish, and obtain the message. Now that I am carefree and at ease, I can pass down the Golden Elixir, and the obtaining of a tiny bit of the divinity is good.

The symbolism of *qing zhicao* is visually recorded in the Yuan dynasty mural painting at the Quanzhen temple complex Yongle Gong 永樂宮 (Temple of Eternal Joy) in Shanxi province. Inside the Chongyang Dian 重陽殿 (Chongyang Hall), a series of forty nine mural paintings are dedicated to the Daoist master Wang Zhe and his disciples. One of the mural sections, entitled *Qing zhicao*, shows Wang "riding on divine clouds and raising the *zhi* plant in his hand." (神雲中手擎芝草)[87] Conceptually and iconographically allied to the image of the Quanzhen master, Shen Zhou pictured himself raising his right hand to show off his possession of the magical plant in the Papp handscroll. The symbolic hand gesture of *qing zhicao*, which is suggestive of his grasping of the key to immortality, provides him a psychological remedy to deal with the emotional predicament engendered by the separation and death of his beloved ones.[88]

The psychological function of *qing zhicao* is parallel to the holding of a *ruyi* scepter in Chinese culture. According to the *Zunsheng bajian* 遵生八牋 (Eight Treatises on the Nurturing of Life) by the Ming scholar-official Gao Lian 高濂 (1573-1620), "*ruyi* was made of iron in the past to prevent unexpected dangers, it was sometimes used to give instructions and directions." (如意，古人以鐵為之，防不測也；時或用以指畫向往。)[89] The *ruyi* scepter, which was often carved in the shape of a *zhi* in Ming and Qing periods, had the similar magical powers of not only granting people the wish of immortality but also of providing them psychological protection.[90] It was treasured by Chinese scholars as auspicious plaything during the Ming and Qing periods. In scholars' studios, the scepter was frequently placed in *ping* 瓶 (vases) on *an* 案 (tables), which make the rebus for *ping'an ruyi* 平安如意, symbolizing "peace and fulfilled wishes."[91] The formal resemblance between the *ruyi* scepter and the *zhi* rendering of the magical plant in a vase on a table undoubtedly suggests the same symbolic meaning.

In Shen Zhou's painting, the artist might have played on the same rebus of *ping'an ruyi* by placing the figures inside the Ping'an Ting and posing himself as a *zhi*-holder. The painting is indeed a well-thought-out work rich in content, deep in emotion, and specific in time. Shen Zhou invests the scene of the specific Mid-Autumn gathering with the hidden symbols of the full moon, pavilion, bridge, willow and *zhi*, as well as the rebus of *pingan ruyi*, in this personal creation whose subtlety and understatement are in perfect conformity with the Chinese scholar-artist ideal. Veiled behind a simple and lucid composition, the intriguing symbols reveal the underlying message not only about Shen Zhou's profound concerns about separation and death but ultimately his personal salvation through the Daoist ideas of longevity and immortality.

Notes to Hidden Meanings of Death

1. For the image and discussion of the painting, see Yi Ruofen 衣若芬, "*Kulou huanxi: Zhongguo wenxue yu tuxiang zhong de shengming yishi* 骷髏幻戲：中國文學與圖象中的生命意識" (Skeleton Puppet Show: The Consciousness of Life in Chinese Literature and Iconography), *Zhongguo wenzhe yanjiu qikan* 中國文哲研究期刊 (Bulletin of the Institute of Chinese Literature and Philosophy) 26 (March 2005): 73-125.

2. The purpose of Lin Daiyu's mortal birth is to repay Jia Baoyu with her tears because Jia is a reincarnation of the *Shenying Shizhe* 神瑛侍者 (Divine Attendant-in-Waiting), who watered her with care and love in their previous lives in heaven. See Cao Xueqin, *Honglou meng* (Taipai: Daidong shuju, 1978), 3.

3. David Hawkes trans., *The Story of the Stone* vol. 2 (London: Penguin Books, 1973), 39.

4. Translation from Ju-hsi Chou, *Journeys on Paper and Silk*, 152.

5. The inscription by Wang Rubi provides the title and authorship of the painting: "In the Xiaoxin Pavilion are kept hundreds of *juan* of ancient texts. After work, I have incense burning and sit quietly amidst these books… The gentleman Pan Xuefeng painted this 'Illusionary Images at the Xiaoxin Pavilion,' to which I add this poem to express my underlying sentiment." (曉心閣藏古書數百卷，公餘焚香靜坐其中…雪峰潘生作曉心夢影圖，予為詩以寫其意。) Translation from Chou with changes, *Journeys on Paper and Silk*, 115.

6. Wang Rubi inscribed on the painting in the year of *Jiayin* 甲寅 (1794) when it was created by Pang Xuefeng. A frontispiece by Yu Ji 余集 (1738-1823) and a colophon by Xie Yong 謝墉 (1719-1795) in the handscroll are both dated 1795.

7. Chou, *Journeys on Paper and Silk*, 116.

8. Translation from Chou with changes, *Journeys on Paper and Silk*, 115.

9. Chou, *Journeys on Paper and Silk*, 116-117.

10. For instance, a poem by the Southern Song ci poet Zhou Mi 周密 (1232-1298) writes about his cousin's Yang Dafang's 楊大芳 grief for his deceased wife using the metaphor *diehua*: "The turning into butterfly inside the curtain [at the mourning hall] can just be a dream. In front of the mirror, the widowed *lun* bird is all but heart-broken." (帳中蝶化真成夢，鏡裏鸞孤枉斷腸。) Zhou Mi, *Kuixin zashi* 癸辛雜識 (Miscellanous Records of the Guixin Year), *qianji*, 26b

11. The turning of the lovers' souls into butterflies is recorded in the *Shantang sikao* 山堂肆考 (Comprehensive Study by Shantang) by the Ming scholar Peng Dayi 彭大翼 (1552-1643): "There is a common belief that large butterflies always appear in pairs, which are the souls of Liang Shanbo and Zhu Yingtai." (俗傳大蝶必成雙，乃梁山伯祝英臺之魂。) Peng Dayi, *Shantang sikao* (SKQS), *juan* 226, 7b.

12. Sigmund Freud, *The Interpretation of Dreams*, trans. A.A. Brill (New York: The Macmillan Company, 1913), 483-492.

13. For a discussion of Huangquan, see Wu Hung, *The Art of the Yellow Springs* (Honolulu: University of Hawaii Press, 2010), 7-8.

14. See Meyer Schapiro, *Words and Pictures: On the Literal and the Symbolic in the Illustration of a Text* (The Hague: Mouton, 1973), 38-39

15. Translation from James Legge, *The Sacred Books of the East*, vol. 3, ed. F Max Müller (Oxford: Clarendon Press, 1879), 441-442.

16. Sima Qian records: "People were dispatched to the seas to search for Penglai, Fangzhang and Yinzhou. These three are the divine mountain (isles), which are said to be located at Bao Sea…" (使人入海求蓬萊 、 方丈 、 瀛洲 ，此三神山者，其傳在渤海中…) Sima Qian, "Treatise on the Feng and Shan Sacrifices," *Shi ji (SKQS)*, *juan* 28, 136.

17. Sima, "Chapter Twelve: Basic Annals of Xiaowu," *Shi ji*, *juan* 12, 25b.

18. According to the *Liexian zhuan* 列仙傳 (Biographies of Exemplary Immortals) by Liu Xiang 劉向 (ca.77-6 BCE), the term *Goushi* 緱氏 refers to the Goushi Mountain, the place where the immortal Wang Ziqiao 王子喬 attained the Dao. Liu Xiang, *Liexian zhuan (SKQS)*, *juan shang*, 13b-14a.

19. The *Zhuangzi* states: "There is a Holy Man living on faraway Gushe Mountain, with skin like ice or snow, who is gentle and shy like a young girl. He doesn't eat the five grains, but sucks the wind, drinks the dew, climbs up on the clouds and mist, rides a flying dragon, and wanders beyond the four seas." (藐姑射之山，有神人居焉，肌膚若冰雪，淖約若處子，不食五谷，吸風飲露，乘雲氣，御飛龍，而游乎四海之外。) Burton Watson trans., *The Complete Works of Chuang Tzu* (New York: Columbia University Press, 1968), 33.

20. For a discussion of the *jiehua* tradition in its historical and cultural contexts, see Anita Chung, *Drawing Boundaries: Architecture Images in Qing China* (Honolulu: University of Hawaii Press, 2004), 9-44.

21. Translation from Chou, *Journeys on Paper and Silk*, 160

22. The poetic lines by the Ming scholar Xu Zhenqing 徐禎卿 (1479-1511), for instance, states: "The immortals are fond of *luibo* and *weiqi*, and currently [they are] in the auspicious green clouds." (仙人好博弈，時下綠雲中。) Xu Zhenqing, *Digong ji* 迪功集 (Collected Works of Digong) (SKQS), *juan* 4, 10a

23. The *Shengxian zhuan* states: "Wang Yuan, *zi* Fangping, was a native of Donghai. He was recommended for his filial piety and honesty to the official position of Langzhong, and was later promoted to the Zhongsan Dafu. He was erudite in the Five Classics… Later he repudiated official life and went into the

mountains to cultivate and finally attained the Dao. The Han emperor Xiaohuan (r. 146-168) heard about him but failed many times to recruit him. (王遠，字方平，東海人也。舉孝廉，除郎中，稍加至中散大夫。博學五經…後棄官入山修道，道成。漢孝桓帝聞之，連徵不出。) Ge Hong, *Shengxian zhuan, juan* 3, 6b-7a.

24. Ge Hong, together with his granduncle Ge Xuan 葛玄 (284-363) and his grandnephew Ge Chaofu 葛巢甫 (fl. 402), were credited for composing and transmitting through their hands a number of texts that established the *Lingbao* 靈寶 (Numinous Treasure) tradition. Stephen R. Bokenkamp, "Ge Chaofu," "Ge Xuan," and Fabrizio Pregadio, "Ge Hong," in Fabrizio Pregadio ed., *Encyclopedia of Taoism* (hereafter *ET*), vol. 1 (Oxon & New York: Routledge, 2008) , 440-445.

25. See Farzeen Baldrian-Hussein, "Lu Dongbin," *ET*, vol. 1, 712-714.

26. The two Daoist immortals are identified through their appearances and attributes. The image of Lu Dongbing has been crystallized in Chinese art as a carefree figure with a topknot carrying a gourd and a big round woven hat. On the other hand, Han Xiangzi is always shown playing the clappers with his left hand and hitting the drumhead with his right hand.

27. In the *Shi ming* 釋名 (Exegesis of Nomenclature) by Liu Xi 劉熙 (fl. ca. 200) of the Eastern Han period, a definition is given to the character: "To become old and attain deathlessness is called *xian*. *Xian* means move away, that is move away into the mountains. Therefore the character is created by using the radical *shan* (mountain) along with the radical *ren* (man)." (老而不死，曰仙。仙，遷也，遷入山也。故其制字，人旁作山也。) Liu Xi, *Shi ming (SKQS)*, *juan* 3, 5b

28. Zhang Chou, *Qinghe shuhuafang (SKQS), juan* 1 *shang*, 19a. The *Xuanhe huapu* 宣和畫譜 (Painting Catalog of the Xuanhe Reign Period) also records that the Northern Song artist Song Di 宋迪 (fl. 1078-1091) addressed the theme in his work. *Xuanhe huapu (SKQS), juan* 12, 3a.

29. *Nan shan* refers to Zhongnan shan 終南山 (Far South Mountain) in Shanxi province, which is a sacred site of Daoism. Its symbolism of longevity and immortality is exhibited in the *Shijing*, which states: "[It is] like the permanence of the moon, like the rising of the sun, and like the age of South Mountain." (如月之恆，如日之升，如南山之壽。) *Maoshi jushu, juan* 16, 39b.

30. Ge Hong, *Shengxian zhuan, juan* 2, 1b-2a.

31. Zhang, *Qinghe shuhuafang, juan* 7 *shang*, 33a.

32. Ju-hsi Chou and Claudia Brown, *The Elegant Brush* (Phoenix: Phoenix Art Museum, 1985), 104. See also, Chou and Brown, *Heritage of the Brush*, 96.

33. The Daoist text is quoted in *Tianzhong ji* 天中記 (Records from Tianzhong) by Chen Yaowen 陳耀文 (1573-1619), See Chen, *Tianzhong ji (SKQS), juan* 43, 25a.

34. Translation from Ju-hsi Chou with changes, *The Elegant Brush*, 104.

35. According to Ge Hong, in order to avoid being attacked by wild animals and vicious spirits of all kinds in the mountains, one should choose the right time to move in and be equipped with special skills as well as protective objects like mirrors and talismans. See Ge Hong, *Baopu zi neiwai pian (SKQS), nei pian, juan* 4, 1a-29a.

36. The *Qian Han shu* 前漢書 (History of the Former Han Dynasty) by Ban Gu 班固 (32-92) gives the annotation: "Cave means to pass through or connect." (洞，通也。) Ban Gu, *Qian Han shu (SKQS), juan* 87 *shang*, 38a.

37. For a phonetic analysis of the term *dongtian*, see Wolfgang Bauer, *China and the Search for Happiness: Recurring Themes in Four Thousand Years of Chinese Cultural History*, trans. Michael Shaw (New York: Seabury Press, 1976), 192.

38. See Miura Kunio, "*Dongtian* and *fudi*," *ET*, vol. 1, 368-372.

39. Tao Yuanming, "Record of Peach Blossom Spring," *Tao Yuanming ji* 陶淵明集 (Collected Works of Tao Yuanming) *(SKQS), juan* 43, 25a.

40. According to the *Shi ming*, the word *qing* 青, known as blue or deep green, originally means "life, like the color of things when they are born/alive." (生也，象物之生時色也。) The word *lu* 綠, or green color, originally denotes "clear water" (瀏也), a meaning also symbolic of life. Liu, *Shi ming, juan* 4, 10a.

41. For instance, the Daoist divine books of records are called *qingshu* 青書 (blue books) and *luji* 綠籍 (green books).

42. The Han text *Shennong bencao jing* 神農本草經 (Classical Pharmacopoeia of the Heavenly Husbandman) notes that malachite could turn copper, iron, lead, and tin all into gold, the desired end product of elixir alchemy. Joseph Needham, *Science and Civilization in China*, vol. 5 part II (Cambridge: Cambridge University, 1974), 209. This canonical book also ranks azurite as one of the superior drugs that could lighten the body and prolong life. Edward H. Schafer, *The Golden Peaches of Samarkand: A Study of Tang Exotics* (Berkeley and Los Angeles: University of California Press, 1963), 178.

43. Several works entitled *Taoyuan tu* 桃源圖 (Painting of Tao[hua] yuan) by Wen Zhengming are recorded in the Ming and Qing art catalogs, such as the *Shuhua tiba ji* 書畫題跋記 (Records of Inscriptions on Paintings and Dalligraphies) by Yu Fengqing 郁逢慶 (ca.1573-ca.1640). See Zhou Daozhen 周道振 ed., *Wen Zhengming shuhua jianbiao* 文徵明書畫簡表 (A Brief Chronological Chart of Wen Zhengming's Paintings and Calligraphies) (Beijing: Renmin meishu chubanshe), 323, 349, 353.

44. At the beginning of the scroll there is a frontispiece, on which the title of the painting was inscribed in seal script by the famous 15th century scholar Li Yingzhen 李應禎 (1431-1493), Shen Zhou's calligraphy teacher.

45. Shen Zhou's poem colophon was inscribed on a separate paper about thirty feet in length. The calligraphy was mounted to the left of the painting in the Papp handscroll.

46. The inscription is recorded in Shen Zhou, *Shitian shixuan* 石田詩選 (Selected Poems of Shitian) (*SKQS*), *juan* 1, 7b-8a. It is also recorded in the *Gengzi xiaoxia lu* 庚子消夏記 (Whiling away the Summer of 1660) by Sun Chengze 孫承澤 (1592-1676), with the two characters *gushi* 古時 (ancient times) replacing *guren* 故人 (old friends) in the handscroll in the Papp collection. Sun Chengze, *Gengzi Xiaoxia lu* (*SKQS*), *juan* 3, 26a-26b.

47. Translation from Chou, *Journeys on Paper and Silk*, 20.

48. Shen Zhou's younger brother Shen Zhao 沈召 (1432-1472) died in 1472, which was followed by the passing of his teachers Chen Kuan 陳寬 (1397-1473) and Du Qiong 杜瓊 (1396-1474) in the next two years, and his father Shen Heng 沈恆 (1409-1477) became seriously ill before his death in 1477. Chen Zhenghong 陳正宏, *Shen Zhou nianpu* 沈周年譜 (Chronicle of Shen Zhou) (Shanghai: Fudan University Press, 1993), 106-135

49. Shen Zhou, "Two Poems after Birthday," *Shitian gao* 石田稿 (Manuscripts of Shen Shitian) (*SKQS*), 163b. (*Xuxiu siku quanshu* 續修四庫全書)

50. Chen Huizhuang had a tumor in her throat which did not cause any pain or itching. But she died suddenly on the twentieth of the fourth lunar month in 1486, just one day after the tumor burst. Chen, *Shen Zhou nianpu*, 196-197.

51. Shen Zhou's annotation to his poem "Celebration of My Sixty-first Birthday" states: "My late wife was born on the same day and month" (亡室同月日生). Shen Zhou, *Shitian shixuan* 石田詩選 (Selected Poems of Shitian) (*SKQS*), *juan* 6, 23a.

52. Shen Zhou, "Enjoying Moon on the Lake at Mid-Autumn," *Shitian shixuan*, *juan* 1, 4a.

53. Shen Zhou, "Mid-Autumn Banquet," *Shitian xianshen ji* 石田先生集 (Collected Works of Master Shitian) (Reprint, Taipei: Guoli zhongyang tushuguan, 1968), 145.

54. Translation from Xu Yuan-zhong, *Selected Poems of Li Bai* (Chengdu: Sichuan People's Publishing House, 1987), 148-150.

55. Wang Bi 王弼 (226-249) annot., *Zhou yi zhu* 周易注 (Commentary on *Zhou yi*) (*SKQS*), *juan* 6, 1b.

56. Zhu Jingxuan, *Tangchao minghua lu* (*SKQS*), 14b.

57. Shen Zhou, "Enjoying Moon at the Night of the Thirteenth of the Eighth Lunar Month. To the Tune of Wave Washing the Sand," *Shitian gao*, 30b.

58. Shen Zhou's *Tianchi ting yue* is recorded in Wang Keyu 汪珂玉 (1587-ca.1647), *Shanhu wang* 珊瑚網 (Coral Net) (*SKQS*), *juan* 37, 14a. His *Qiuting huayue* is recorded in Bian Yongyu, *Shigu Tang shuhua huikao, juan* 55, 48b.

59. Li Bai's famous "Laolao Pavilion" states: "There is no place that oftener breaks the heart than the Pavilion seeing people part. The wind of early spring knows parting grieves, it will not green the roadside willow leaves." (天下傷心處，勞勞送客亭。春風知別苦，不遣柳條青。) Translation from Xu, *Selected Poems of Li Bai*, 174. Shen Zhou uses the Laolao Pavilion as literary allusion in one of his farewell poems: "Just after a brief reunion, we have to part again; reading the Laolao Poem, I saw the small pavilion in autumn rain." (只暫相逢又相別，短亭秋雨賦勞勞。) Shen Zhou, "Chen Qidong's Return to Jiyang after Examining Papers in Zhe[jiang] Province," *Shitian xianshen ji*, 490.

60. The number of figures depicted in the Papp scroll has been discussed by Ju-hsi Chou. See Chou, *Journeys on Paper and Silk*, 18.

61. A statement by Shen Zhou was inscribed on her tombstone as epitaph: "My wife truly was my good friend.... She came from an illustrious family and had an unassuming, gentle, and calm disposition." (吾之妻，吾良友也⋯ 是名家子，性夷澹柔靜。) Quoted from Chen, *Shen Zhou nianpu*, 44.

62. For instance, the famous Ba/Baling Qiao 霸/霸陵橋 (Ba/Baling Bridge) in the Tang capital Chang'an 長安 became a synonym for the sorrowful farewell of relatives and friends: "Ba Bridge spanned over the water, where people of the capital saw friends off and snapped willow twigs as farewell gifts." (霸橋跨水作橋，都人送客至此，折柳贈別。) Liu Yuyi 劉於義 (1675-1748) et al. comp., *Shanxi tongzhi* 陝西通志 (General Annals of Shanxi) (*SKQS*), *juan* 16, 8a. Shen Zhou wrote of a sentimental send-off with reference to Baling Bridge and willow twigs: "Chuihong is not the Baling Bridge, it is a long way to come here to see friends off... We drown in the waves of wine and play with the lotus leaves. Busy thoughts of separation lie on the willow twigs." (垂虹不是灞陵橋，送客能來路亦遙⋯酒波汩汩翻荷葉，別思忙忙在柳條。) Quoted in Wang, *Sanhu wang*, *juan* 14, 6b-7a.

63. In one of Bai Juyi's lyric poems about willow twigs, *zheliu* vividly resonates with *duanchang* 斷腸 (breaking of intestines), signifying heartbreaking separation: "People say that willow leaves look like sad eyebrows, and the sad intestines resemble slender willow twigs. To pull and snap the willow twigs is to pull and break the intestines, those separated probably could never be together again." (人言柳葉似愁眉，更有愁腸似柳絲。柳絲挽斷腸牽斷，彼此應無續得期。) Bai Juyi, "Eight Lyric Poems on Willow Twigs," *Bai Xiangshan shiji, juan* 32, 22a.

64. Wolfram Eberhard has explored the symbolic meanings of the willow in Chinese culture, especially those related to sex and women. Eberhard, *A Dictionary of Chinese Symbols*, 314.

65. See Wolfram Eberhard, *Chinese Festivals* (New York: Henry Schuman, 1952), 97, 104. This common practice is manifested in the old saying: "Men must not worship the moon, women must not sacrifice to the Kitchen God." (男不拜月，女不祭社。) Quoted from Julit Bredon and Igor Mitrophanow, *The Moon Year: A Record of Chinese Customs and Festivals* (Shanghai: Kelly & Walsh, 1927), 399.

66. This speculation is proposed by Howard Rogers in his catalog essay. See Rogers, "Shen Zhou," *Kaikodo Journal* 6 (1996): 18.

67. This interpretation of the motif is presented in Chun-yi Lee, "Quest for Immortality: Shen Zhou's Watching the Mid-Autumn Moon at Bamboo Villa" (M.A. thesis, Arizona State University, 2004) 41-53; Chun-yi Lee, "The Immortal Brush: Daoism and the Art of Shen Zhou (1427-1509)" (Ph.D. dissertation, Arizona State University, 2009), 228-238. The author is currently adapting the thesis and dissertation into a book on Shen Zhou's art and Daoist symbols and themes.

68. Shen Zhou poses himself as the frontal figure with a potential eye-engagement with the beholder so as to draw our attention to the symbolism of the *zhi* in his right hand and to communicate some sense of his personal situation. Lee, "Quest for immortality," 42-43.

69. Xu Shen 許慎 (ca.58-ca.147), *Shuowen Jiezi* 說文解字 (Explaining Simple and Analyzing Compound Characters) (*SKQS*), *juan* 1 xia, 2a.

70. One of the earliest records about the magical function of *lingzhi* is from the *Li ji* of the late Zhou or early Han periods, in which the plant is listed as a ritual food of emperors. *Li ji zhushu*, *juan* 27, 20b.

71. "Basic Annals of the Emperor Xiaowu," *juan* 12, 25a, 26a-26b.

72. Sun Xingyan and Sun Fengyi eds., *Shennong ben cao jing* (1891; reprint, Taipei: Taiwan Zhonghua Shuju, 1976), 23. The *Shennong bencao jing* is a compilation of oral traditions of *materia medica* knowledge written between about 300 BCE and 200 AD. The original text no longer exists and the most popular edition is one edited by Sun Xingyan 孫星衍 (1753-1818) and Sun Fengyi 孫馮翼 (fl. 1801) in the Qing period.

73. The origin of the symbolism of *lingzhi* has been a topic of scholarly debate. Michael Suillvan regards it as indigenous to China while Gordon Wasson believes the fungal symbolism came from India and was a literary reflection of Soma. Michael Sullivan, *The Birth of Landscape Painting in China*, 178-180; Gordon Wasson, *Soma: Divine Mushroom of Immortality* (New York: Harcourt, Brace & World, 1968), 80-81. The Han use of the symbolism of *zhi* is exemplified in the *Liexian zhuan*, in which Liu Xiang states that the legendary Pengzu 彭祖 lived "from the Xia to Shang dynasties for more than eight hundred years by frequently consuming the cinnamon *zhi*." (歷夏至殷末八百餘歲，常食桂芝。) Liu Xiang, *Liexian zhuan*, *juan shang*, 8b.

74. For instance, the Qing encyclopedia *Yuding yuanjian leihan* 御定淵鑒類函 (Infinite Mirror and Classified Treasure Chest Granted by the Emperor) records more than a hundred textual references to *zhi* from various dynasties. Zhang Ying 張英 (1637-1708) et al. eds., *Yuding yuanjian leihan* (*SKQS*), *juan* 108, 14b-25b.

75. An inscription on the painting by Wu Hufan 吳湖帆 (1894-1968) states that the set of scrolls were painted by Lu Hui for his grandfather Wu Dazheng's 吳大澂 (1833-1902) 60th birthday.

76. The five major types of *zhi* are identified by Ge Hong as *shizhi* 石芝 (rock *zhi*), *muzhi* 木芝 (wood *zhi*), *caozhi* 草芝 (herb *zhi*), *rouzhi* 肉芝 (flesh *zhi*), and *junzhi* 菌芝 (fungus *zhi*). Ge further points of that each of these five types has more than a hundred sub-types. Ge Hong, *Baopu zi neiwai pian, nei pian juan* 2, 39b-46b.

77. For instance, the famous *Rhapsody of Contemplating the Mystery* by Zhang Heng 張衡 (78-139) states: "To stay at Yingzhou and pluck *zhi* is only for the pursuit of immortality." (留瀛洲而採芝兮，聊且以乎長生。) Quoted in Fan Ye, "Biographies Chapter Forty Nine: Zhang Heng," *Hou Han shu*, *juan* 89, 22a

78. One of the earliest examples can be found on the relief decoration of a stone brick excavated from a Han dynasty tomb at Nanyang 南陽 in Hunan province, in which two winged immortals are shown walking on the clouds and grasping *zhi* in their hands. Nanyang Wenwu yanjiusuo 南陽文物研究所 ed., *Nanyang Handai huaxiangzhuan* 南陽漢代畫像磚 (Decorated Tomb Bricks at Nanyang) (Beijing: Wenwu chubanshe, 1990), 127.

79. *Xuanhe huapu*, *juan* 1, 8b; *juan* 3, 6a.

80. Dong Yuan's painting is listed in Bian Yongyu 卞永譽 (1645-1712), *Shigutang shuhua huikao* 式古堂書畫匯考 (Investigation of Painting and Calligraphies from the Shigu Tang) (*SKQS*), *juan* 33, 26a. Gu Deqian's painting is recorded in *Xuanhe huapu*, *juan* 4, 7b.

81. Bian, *Shigu tang shuhua huikao*, *juan* 33, 26a.

82. Lu You, "Grasping Cinnabar *Zhi* at Yulong," *Jiannan shigao* 劍南詩藁 (Collected Poems of Jiannan) (*SKQS*), *juan* 13, 1b. For the image of the woodblock illustration, see Wang Qi 王圻 (1530-1615) comp., *Sancai tuhui* 三才圖繪 (Tripartite Picture Assembly), vol.2 (reprint, Taipei: Chengwen chubanshe, 1970).

83. Shen Zhou, "Connecting Poetic Lines at Ziyi Studio," *Shitian gao*, 53a.

84. Liu Chuxuan, *Huangting neijing yujing zhu* 黃庭內景玉經注 (Commentary to the Jade Scripture of the Inner Effulgences of the Yellow Court) (Zhengtong Daozang 401) (Reprint, Taipei: Xinwenfeng chubanshe, 1988), 32a.

85. Wang Zhe, "Fascinating River Moon," *Chongyang Quanzhen ji* 重陽全真集 (Anthology on the Completion of Authenticity by Zhongyang) (Zhengtong Daozang 1153), *juan* 3. See the inscription that accompanies the figure of Wang Zhe in this mural section. Jin Weinuo 金維諾 ed., *Yongle Gong bihua quanji* 永樂宮壁畫全集 (Complete Collection of Mural Paintings in the Yongle Palace) (Tianjin: Tianjin renmin meishu chubanshe, 1997), 262.

86. Shen Zhou's seeking for a psychological remedy can be further substantiated by his depiction of the unusual structure of the pavilion and the placement of the three figures. Although the design of the pavilion varies widely in China, the one with railings on only one side as shown in the painting is rarely found in reality. Most of the pavilions, like those depicted by Shen Zhou in his other paintings, indeed have railings on three sides, on four sides with a small entrance, or have no railings at all. It is odd to place them on the left side of the Pavilion which has no safety function because the river is on another side. Such arrangement seems to block the way to the bridge on the left as a means of psychological protection from the grief and loss associated with the bridge. This is probably the reason why the three figures are seated close together in the right corner of the pavilion. In fact they should sit near the railings on the left so they could have a better view of the Mid-Autumn moon without being intercepted by the thatch.

87. Gao Lian, *Zunsheng bajian (SKQS), juan* 8, 15b.

88. The imitation of *ruyi* in the shape of *zhi*, as well as the similar way they are held in hands in visual representations, sometimes bring difficulties to the identification of these two motifs in later Chinese painting. In a portrait of Qianlong, for instance, the Qing emperor is dressed like a Daoist priest, and the object in his right hand is identified by Richard Vinograd as a *zhi*. However, the object also looks like a *ruyi* scepter. Richard Vinograd, *Boundaries of the Self: Chinese Portraits 1600-1900* (New York: Cambridge University Press, 1992), 71.

89. The rebus *pingan ruyi* has been widely discussed. Edouard Chavannes, *The 5 Happinesses: Symbolism in Chinese Popular Art*, trans. Elaine Spaulding Atwood (New York & Tokyo: Weatherhill, 1973), 19. Fang Jing Pei et al., *Treasures of the Chinese Scholar* (New York & Tokyo: Weatherhill, 1997), 137. Terese Tse Bartholomew, *Hidden Meanings in Chinese Art*, 265.

90. In an anonymous Ming dynasty painting entitled *Scholar Taking His Ease* in the Freer Gallery of Art in Washington, D.C., a long inscription about Daoist longevity attests the symbolism of the *zhi* in a vase on a table. See Thomas Lawton. *Chinese Figure Painting* (Washington D.C.: Freer Gallery of Art, 1973), 161. See also, Fang Jing Pei, *Symbols and Rebuses in Chinese Art: Figures, Bugs, Beasts, and Flowers* (Berkeley: Ten Speed Press, 2004), 113.

91. It was customary to use puns in Chinese painting. For instance, one of Shen Zhou's works in the Tokyo National Museum was given the title *Wanshou Wujiang* 萬壽吳江, in which Wujiang (Wu River) is homophonous with *wujiang* 無彊 (boundless), suggesting boundless longevity. For the images of the scroll, see Kei Suzuki comp., *Comprehensive Illustrated Catalog of Chinese Paintings*, vol. 3 (Tokyo: University of Tokyo Press, 1983), 84-85.

Catalog in chronological order

Paintings related to the theme of love:

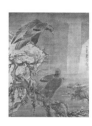

1. [4] Page 20 and 21
Chen Zihe 陳子和 (fl. late 15th – early 16th century)
Two Eagles 雙鷲圖軸, undated.
Hanging scroll, ink on silk, 146 x 108 cm.
Published: *Journeys on Paper and Silk*, catalog number 6.
Collection of Roy and Marilyn Papp

2. [16] Page 34
Wu Shi'en 吳世恩 (active ca. 1500)
Liang Hong and Meng Guang 舉案齊眉圖軸, undated.
Hanging scroll, ink and color on silk, 142.1 x 81.2 cm.
Published: *Scent of Ink*, catalog number 2; *Le Parfum de l'encre*,
catalog number 2; Xiaoping Lin, "Wu Shi'en's Liang Hong and
Meng Guang: A Misreading," *Phoebus* 9, *Myriad Points of View*,
page 80, figure 1.
Collection of Roy and Marilyn Papp

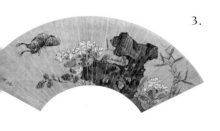

3. [12] Page 30
Lan Ying 藍瑛 (1585-1660)
Butterfly, Red Bamboo and Gardenias by a Rock 栀蝶竹石圖, undated.
Fan, mounted as a hanging scroll, ink and color on gold paper,
16.7 x 52 cm. Published: *Journeys on Paper and Silk*, catalog number 14;
Kaikodo Journal V (autumn 1997, dealer's cat.), catalog number 15.
Collection of Roy and Marilyn Papp

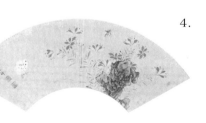

4. [13] Page 30
Wen Shu 文淑 (1595-1634)
Flowers and Rock 花石圖, undated.
Matted fan, ink and color on gold paper, 15.9 x 49.5 cm.
Published: *Heritage of the Brush*, catalog number 11.
Collection of Roy and Marilyn Papp

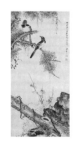

5. [2] Page 18
Chen Jiayan 陳嘉言 (1599 - after 1679)
Two Magpies in a Pine 松梅雙喜圖軸, dated 1664
Hanging scroll, ink and color on paper, 130.8 x 59.7 cm
Published: *Journeys on Paper and Silk*: catalog number 20;
Kaikodo Journal V (Autumn 1997, dealer's cat.), catalog number 16.
Collection of Roy and Marilyn Papp

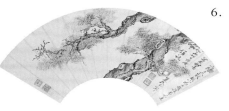

6. [1] Page 16
Mao Xiang 冒襄 (1611 – 1693) and Cai Han 蔡含 (1647-1684)
Old Pine Tree 虬松圖, undated.
Fan mounted as a hanging scroll, ink on paper, 19 x 57.9 cm.
Published: *Journeys on Paper and Silk*, catalog number 25.
Collection of Roy and Marilyn Papp

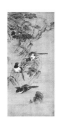

7. [3] Page 19 and 43
Tong Yuan 童原 (active 17th century)
Birds on a Branch 枝頭雀鳥圖軸, undated.
Hanging scroll, ink and color on silk, 134.3 x 66.3 cm.
Published: *Journeys on Paper and Silk*, catalog number 22.
Collection of Roy and Marilyn Papp

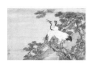
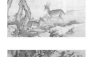

8. [6] Page 24, [7] Page 25, and [8] Page 26
Shen Quan 沈佺 (1682 - ca. 1760)
Monkeys 猴; *Cranes* 鶴; *Deer* 鹿, dated 1740.
3 album leaves from an album of 12 leaves, ink and color on silk,
each leaf 20.6 x 31 cm.
Published: *Journeys on Paper and Silk*, catalog number 35;
"Among Flora and Fauna," *Kaikodo Journal* V (autumn 1997,
dealer's cat.), catalog number 26;
Phoebus 9, *Myriad Points of View*, pages 22-23, catalog number 4.
Phoenix Art Museum, gift of Marilyn and Roy Papp, 2005.133.B, E, F

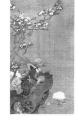

9. [5] Page 23
Wang Zheng 王正 (fl. late 17th - early 18th century)
Pheasants under a Crabapple Tree 海棠雉雞圖軸, undated.
Hanging scroll, ink and color on silk, 183 x 95 cm.
Published: *Heritage of the Brush*, catalog number 21.
Collection of Roy and Marilyn Papp

10. [9] Page 27, [10] Page 28, and [11] Page 29
Qian Weicheng 錢維城 (1720-1772)
Lotus and Root 荷藕; *Butterflies Hover above Pinks and Aster* 菊蝶;
A Cicada Alighting on a Willow Branch 蟬柳, dated 1762.
3 album leaves from an album of eleven leaves,
ink or ink and color on paper,
each leaf 24 x 29 cm.
Published: *Scent of Ink*, catalog number 28; *Le Parfum de l'encre*,
catalog number 25.
Phoenix Art Museum, gift of Marilyn and Roy Papp,
2007.200.B, G, I

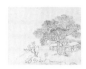

11. [14] Page 31
Kuai Jiazhen 蒯嘉珍 and Qian Yuling 錢与齡 (fl. mid 18th century)
Landscape 山水, undated.
An album leaf from an album of 10 leaves, ink on paper,
each leaf: 9.8 x 14 cm.
Published: *Journeys on Paper and Silk*, catalog number 38.
Collection of Roy and Marilyn Papp

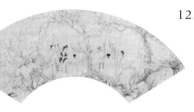

12. [17] Page 34 and 35
Gu Luo 顧洛 (1763 - after 1837)
Painting a Portrait of Yang Consort (Yang Guifei) 楊妃寫照圖, undated.
Folding fan, ink and color on paper, 18 x 57.1 cm.
Published: *Journeys on Paper and Silk*, catalog number 47;
Marion S. Lee, "Pleasure and Pain," *Phoebus* 9, *Myriad Points of View*,
page 151, figure 3.
Collection of Roy and Marilyn Papp

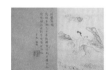

13. [18, 19, 20, 21, 22, 23] Page 37
Gai Qi 改琦 (1773-1829)
Lady Hongfu Combing Her Hair 紅拂梳頭; *Cailuan Copying the Rhyme
Dictionary* 彩鸞寫韻; *Meng Guang Carrying an Urn* 孟光提甕;
The Girl-weaver Crossing the Milky Way 織女渡河; *Luofu Harvesting
Mulberry Leaves* 羅敷采桑; *The Qiao Sisters Reading Books Together*
二喬觀書, dated 1799. 6 leaves from an album of 16 leaves of
painting and 18 leaves of calligraphy, ink on paper,
each leaf: 25 x 17.4 cm.
Published: *Journeys on Paper and Silk*, catalog number 44;
Chu-tsing Li, "Looking at Late Qing Painting with New Eyes,"
Phoebus 8, *Art at the Close of China's Empire*, page 32, fig. 4;
Janet M. Theiss, *Disgraceful Matters: The Politics of Chastity in
Eighteenth-Century China*, Berkeley, CA: University of California Press,
2005, cover; Marion S. Lee, "Pleasure and Pain," *Phoebus* 9,
Myriad Points of View, page 153, fig. 4.
Collection of Roy and Marilyn Papp

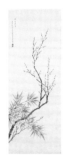

14. [15] Page 33
Dong Wanzhen 董琬貞(1776-1849)
Purity through an Icy Window 寒窗清逸圖軸, dated 1830.
Hanging scroll, ink and color on paper, 103.8 x 37.8 cm.
Published: *Transcending Turmoil: Painting at the Close of China's Empire,
1796-1911*, catalog number 33; *Journeys on Paper and Silk*,
catalog number 49.
Collection of Roy and Marilyn Papp

Paintings related to the theme of death:

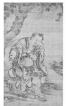

15. [16, 17, 18] Frontispiece, Page 70, 71, 72, and 76
Shen Zhou 沈周 (1427-1509)
Watching the Mid-Autumn Moon at Bamboo Villa 有竹庄中秋賞月圖卷,
dated c. 1486. Handscroll, ink on paper, 29.3 x 92 cm.
Published: *Journeys on Paper and Silk*, catalog number 1;
Kaikodo Journal (autumn 1996, dealer's cat.), catalog number 6;
Phoebus 9, Myriad Points of View, pages 52-53, figure 2; Chun-yi Lee,
The Immortal Brush: Daoism and the Art of Shen Zhou (1427-1509),
PhD dissertation, Arizona State University, 2009.
Collection of Roy and Marilyn Papp

16. [10] Page 62
Wang Zheng 王政 (fl. 15th century)
Two Immortals 二仙圖屏, undated.
A pair of panels, ink and color on silk, each panel: 155.5 x 85.7 cm.
Published: *Heritage of the Brush*, catalog number 1.
Phoenix Art Museum, gift of Marilyn and Roy Papp, 2009.50

17. [9] Page 60 and 61
Zhao Changguo 趙昌國 (fl. 16th century)
Immortals Playing Weiqi in the Mountains 臨戴進秋山仙奕圖軸, undated.
Hanging scroll, ink on paper, 143.5 x 57.5 cm.
Published: *Journeys on Paper and Silk*, catalog number 9.
Collection of Roy and Marilyn Papp

18. [8] Page 59
Anonymous 佚名 (16th century)
Landscape 山水圖軸, undated
Hanging scroll, ink and color on silk, 173.5 x 47cm.
Published: *Heritage of the Brush*, catalog number 2.
Collection of Roy and Marilyn Papp

19. [13] Page 66
School of Lan Ying 藍瑛畫派 (1585-1660)
Peach-blossom Spring 桃花源圖軸, undated.
Hanging scroll, ink and color on silk, 193.7 x 69 cm.
Published: *Journeys on Paper and Silk*, catalog number 15.
Collection of Roy and Marilyn Papp

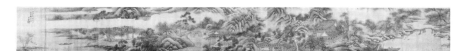

20. [14] Page 68 and 69
Wen Nan 文枬 (1596-1667)
In Search of Plum Blossoms 山水人物圖卷, dated 1637.
Handscroll, ink and color on silk, 22.5 x 210.9 cm.
Published: *Scent of Ink*, catalog number 8; *Le Parfum de l'encre*,
catalog number 9.
Collection of Roy and Marilyn Papp

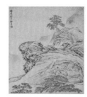
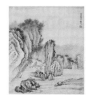

21. [12 Leaf C and H] Page 65
Shangguan Zhou 上官周 (1665 - c.1750)
Landscapes 山水: *Playing the Qin for a Receptive Audience* 梅琴聽者知音;
Sighing Wistfully at a Pot of Flowers 花塢鐏前微嘆, dated 1738.
2 album leaves from an album of 12 leaves, ink and color on paper,
each leaf 34.5 x 28.5 cm.
Published: *Scent of Ink*, catalog number 23; *Le Parfum de l'encre*,
catalog number 25; *Phoebus 9, Myriad Points of View*, page 19,
catalog number 3.
Phoenix Art Museum,
gift of Marilyn and Roy Papp, 2005.132.C, H

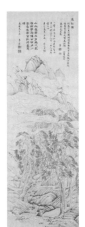

22. [11] Page 63
Qian Feng 錢灃 (1740-1795)
Ten Thousand Pines 萬松圖軸, dated 1782.
Hanging scroll, ink on paper, 109.2 x 34.3 cm.
Published: *The Elegant Brush: Chinese Painting Under the
Qianlong Emperor 1735-1795*, catalog number 33;
Heritage of the Brush, catalog number 34;
Osvald Sirén, *Chinese Painting: Leading Masters and Principles*, New York,
1956-1958, VII, 308; *Phoebus 9, Myriad Points of View*, page 41,
catalog number 16.
Phoenix Art Museum,
gift of Marilyn and Roy Papp, 2005.130

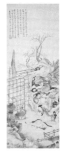

23. [1] Page 50 and 51
Gu Luo 顧洛 (1763-after 1837)
Lin Daiyu Burying Fallen Blossoms 黛玉葬花圖軸, undated.
Hanging scroll, ink and color on paper, 86.4 x 30.7 cm.
Published: *Transcending Turmoil: Painting at the Close of China's Empire,
1796-1911*, catalog number 32; *Journeys on Paper and Silk*,
catalog number 46.
Collection of Roy and Marilyn Papp

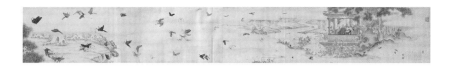

24. [2, 3, 4, 5] Cover, Page 52, 53, 54, 55, and 96
Pan Xuefeng 潘雪峰 (fl. 18th century)
Dreaming in the Xiaoxin Pavilion 曉心夢景圖卷, dated 1794.
Handscroll, ink and color on paper, 47.3 x 333.7 cm.
Published: *Journeys on Paper and Silk*, catalog number 39; *Phoebus 9,*
Myriad Points of View, pages 42-43, catalog number 17.
Phoenix Art Museum, gift of Marilyn and Roy Papp, 2005.129

25. [15] Page 70
Liu Yanchong 劉彥沖 (1809-1847)
Blue-and-green Landscape 青綠山水圖軸, dated 1834.
Hanging scroll, ink and color on paper, 106 x 38.3 cm.
Published: *Scent of Ink*, catalog number 43; *Le Parfum de l'encre,*
catalog number 45.
Collection of Roy and Marilyn Papp

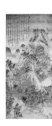

26. [6] Page 57
Su Renshan 蘇仁山 (1814-1850)
Landscape 山水圖軸, dated 1829.
Hanging scroll, ink and color on silk, 212.4 x 92.7 cm.
Published: *Journeys on Paper and Silk*, catalog number 50.
Collection of Roy and Marilyn Papp

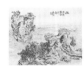

27. [7] Page 58
Wu Tao 吳滔 (1840-1895)
Landscape: In the Manner of Siweng's (Dong Qichang) Journey to Xichuan
山水：仿思翁游西川圖, undated. An album leaf from an album of
six leaves, ink and color on paper, each leaf 27.7 x 34.6 cm.
Published: *Scent of Ink*, catalog number 46; *Le Parfum de l'encre,*
catalog number 48.
Collection of Roy and Marilyn Papp

28. [19] Page 77
Hu Zhang 胡璋 (1848-1899)
Refined Enjoyment by the Eastern Fence 東籬清趣; *Pine and Fungi*
Celebrating Long Life 松芝獻壽, undated. Hanging scroll from a pair
of scrolls, ink and color on silk, 127 x 14.6 cm.
Published: *Scent of Ink*, catalog number 47; *Le Parfum de l'encre,*
catalog number 49.
Collection of Roy and Marilyn Papp

29. [20] Page 77

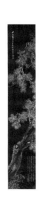

Lu Hui 陸恢 (1851-1920)

Fungus and Cypress 芝草柏樹, dated 1894.

Hanging scroll from a set of eight scrolls, metallic pigment on indigo paper, 139 x 23.5 cm.

Published: *Transcending Turmoil: Painting at the Close of China's Empire, 1796-1911*, catalogue number 79; *Scent of Ink*, catalog number 50; *Le Parfum de l'encre*, catalog number 52.

Phoenix Art Museum, gift of Marilyn and Roy Papp, 2006.169.H

Select Bibliography

Bartholomew, Terese Tse. *Hidden Meanings in Chinese Art.* San Francisco: Asian Art Museum – Chong-Moon Lee Center for Asian Art and Culture, 2006.

Bertholet, Ferdinand M. *Gardens of Pleasure: Eroticism and Art in China.* Munich: Prestel, 2003.

Michel Beurdeley. *Chinese Erotic Art*, trans. Diana Imber. Rutland & Tokyo: Charles E. Tuttle, 1969.

Brown, Claudia, and Ju-hsi Chou. *Transcending Turmoil*: *Painting at the Close of China's Empire, 1796-1911.* Exh. cat.: Phoenix Art Museum, 1992.

Brown, Claudia, ed. *Myriad Points of View, Phoebus* 9 (2006).

Cahill, James. *Pictures for Use and Pleasure: Vernacular Painting in High Qing China.* Berkeley: University of California Press, 2010.

Chavannes, Edouard. *The 5 Happinesses: Symbolism in Chinese Popular Art*, trans. Elaine Spaulding Atwood. New York & Tokyo: Weatherhill, 1973.

Chou, Ju-hsi, ed. *Art at the Close of China's Empire, Phoebus* 8 (1998).

Chou, Ju-hsi and Claudia Brown. *The Elegant Brush: Chinese Painting Under the Qianlong Emperor, 1735-1795.* Exh. cat.: Phoenix Art Museum, 1989.

Chou, Ju-hsi and Claudia Brown. *Heritage of the Brush*: *The Roy and Marilyn Papp Collection of Chinese Painting.* Exh. cat.: Phoenix Art Museum, 1989.

Chou, Ju-hsi and Claudia Brown. *Journeys on Paper and Silk*: *The Roy and Marilyn Papp Collection of Chinese Painting.* Exh. cat.: Phoenix Art Museum, 1998.

Chou, Ju-hsi and Claudia Brown. *Scent of Ink*: *The Roy and Marilyn Papp Collection of Chinese Painting.* Exh. cat.: Phoenix Art Museum, 1994.

Anita Chung. *Drawing Boundaries: Architecture Images in Qing China.* Honolulu: University of Hawaii Press, 2004.

Eberhard, Wolfram. *Chinese Festivals.* New York: Henry Schuman, 1952.

Fang, Jing Pei. *Symbols and Rebuses in Chinese Art*: *Figures, Bugs, Beasts, and Flowers.* Berkeley: Ten Speed Press, 2004.

Franzblau, Abraham N. *Erotic Art of China*: *A Unique Collection of Chinese Prints and Poems Devoted to the Art of Love.* New York: Crown Publishers, 1977.

Gournay, Antoine, ed. *Le Parfum de l'encre*: *Peintures chinoises de la collection Roy et Marilyn Papp.* Exh. cat., Paris: Musée Cernuschi, 1999.

Gulik, Robert Hans van. *Erotic Colour Prints of Ming Period*: *With an Essay on Chinese Sex Life from the Han to the Ch'ing Dynasty, B.C. 206-A.D. 1644.* Reprint, Leiden and Boston: Brill, 2004.

Gulik, Robert Hans van. *Sexual Life in Ancient China; A Preliminary Survey of Chinese Sex and Society from ca. 1500 B.C. Till 1644 A.D.* Leiden: E. J. Brill, 1961.

Laing, Ellen Johnston. "Chinese Palace-Style Poetry and the Depiction of a Palace Beauty." *The Art Bulletin* 72.2 (June, 1990): 284-295.

Laing, Ellen Johnston. "Erotic Themes and Romatic Heroines Depicted by Ch'iu Ying."
 Archives of Asian Art 49 (1996): 68-91.

Lee, Chun-yi. "The Immortal Brush: Daoism and the Art of Shen Zhou (1427-1509)."
 Ph.D. dissertation, Arizona State University, 2009.

Little, Stephen with Shawn Eichman. *Taoism and the Arts of China.* Exh. cat.:
 The Art Institute of Chicago, 2000.

National Palace Museum, Taipei. *Shi nu hua zhi mei* 仕女畫之美 (Glimpses into the
 Hidden Quarters: Paintings of Women from the Middle Kingdom). Taipei:
 Gu gong bo wu yuan (National Palace Museum), 1988.

Jan Stuart. "Two Birds with the Wings of One: Revealing the Romance in Chinese Art."
 In *Love in Asian Art & Culture*, edited by Karen Sagstetter ed. Washington D.C.:
 Arthur M. Sackler Gallery, 1998, 11-29.

Richard Vinograd. *Boundaries of the Self: Chinese Portraits 1600-1900.* New York:
 Cambridge University Press, 1992.

Wang Yaoting. "Images of the Heart: Chinese Paintings on a Theme of Love."
 National Palace Museum Bulletin 22.5 (Nov/Dec, 1988):
 1-21; 22.6 (January/February, 1988): 1-21.

Acknowledgements

Leesha Alston

Jennifer Barnella

Kathryn Blake

Ana Cox

Deborah Deacon

Bob Gates

Zack Glover

Ming Hua

Jiejing (Amy) Huang

Gene Koeneman

David Restad

Momoko Welch

Laura Wenzel

Lee Werhan

Visiting scholars and presenters for the
Marilyn and Roy Papp ASU – Phoenix Art Museum –
Asian Arts Council Chinese Painting Program

2007 Arnold Chang (Zhang Hong), painter and Chinese art expert,
 former Vice-President, Sotheby's

2008 Howard Rogers, Professor Emeritus, Sophia University, Tokyo, and
 Founding Director, *Kaikodo*

2009 Chun-yi Lee, Doctoral Fellow Arizona State University,
 now Assistant Professor, National Taiwan Normal University

2010 Robert D. Mowry, Alan J. Dworsky Curator of Chinese Art,
 Harvard Art Museum
 and
 An-yi Pan, Associate Professor, History of Art and Visual Studies,
 Cornell University
 with ASU doctoral students: Shiloh Blair, Jacqueline Jennifer Chao,
 Ming Hua, and Chen Liu

2011 Anita Chung, Curator of Chinese Art, The Cleveland Museum of Art
 A program in honor of Ju-hsi Chou, Professor Emeritus, ASU, and former
 Senior Curator of Chinese Art, The Cleveland Museum of Art

2012 Richard Vinograd, Christensen Fund Professor in Asian Art,
 Stanford University

2013 ASU students:
 undergraduate: Pin-Yi Li
 graduate (MA): Yijing Wang
 doctoral: Ming Hua, Xuewen Liu, Momoko Welch, and Yang Wu
 doctoral fellow: Chen Liu

zhixin wuya 知心無涯
(boundless intimacy)